Birthday Presents

Birthday Presents

Acquisitions for the 100th Anniversary

of the Busch-Reisinger Museum,

Harvard University

Edited by Peter Nisbet, with contributions by
Joachim Homann, Lisa Lee, Laura Muir,
Peter Nisbet, and Adrian Sudhalter

Harvard University Art Museums
Cambridge, Massachusetts

Support for this publication has been provided by the Andrew W. Mellon Publication Fund.

Library of Congress Cataloging-in-Publication Data

Birthday presents : acquisitions for the 100th anniversary of the Busch-Reisinger Museum, Harvard University / edited by Peter Nisbet ; with contributions by Joachim Homann ... [et al.].

 p. cm.

 ISBN 1-891771-37-X (alk. paper)

1. Art, German—20th century—Catalogs. 2. Busch-Reisinger Museum—Catalogs. 3. Art—Massachusetts—Cambridge—Catalogs. I. Nisbet, Peter. II. Homann, Joachim. III. Busch-Reisinger Museum.

N6868.B574 2003

708.144′4—dc22 2003019412

Produced by the Publications Department
Harvard University Art Museums
Evelyn Rosenthal, Head of Publications
Edited by Carolann Barrett and Marsha Pomerantz
Designed by Becky Hunt
Printed by MacDonald & Evans, Braintree, Mass.

Cover:
Ernst Wilhelm Nay, *Seraphim*, 1964. Oil on canvas, 162 x 150.7 cm. Gift of the Acquisitions Committee of the Friends of the Busch-Reisinger Museum on the occasion of the 100th Anniversary of the Museum, 2003.64.

Contents

Director's Foreword

Over the past 380 years, Harvard has constantly reinvented itself and multiplied into many institutions and faculties, which themselves have had protean lives. At times, the names have changed: Gore became Widener. Or the names stayed the same and the forms transformed: the library's greatest benefactor prior to Christopher Gore, the eighteenth-century Englishman Thomas Hollis, became ubiquitous at the turn of the twenty-first century as HOLLIS, the Harvard Online Library Information System.

And so the Germanic Museum, the invention of a charismatic professor in Harvard's German Department, which a century ago housed its collection of plaster casts of medieval sculpture in a gymnasium, in 2003 is the Busch-Reisinger Museum, featuring modern and contemporary art in the sleek, purpose-built galleries of Werner Otto Hall. In the intervening hundred years, the Museum's collections and programs, a miscellany of periods and genres, were in the architectural zoo now known as Adolphus Busch Hall. Has the institution remained faithful to its founder and committed to its mandate?

Yes, I am confident that it has, just as I am confident that Thomas Hollis, born and died before the invention of the card catalogue, would be delighted by the electronic database that disseminates "his" library's information worldwide. The Busch-Reisinger Museum today, through all its changes, retains its comprehensive original vision: to understand, interpret, and celebrate the visual culture of Northern Europe—narrowly Germanic, more widely that of adjacent nations and regions as well.

Perhaps this focus was first adopted to counterbalance the preeminence and prestige at Harvard in 1903 of Professor Charles Eliot Norton, who had given the study of Italian art and culture a quarter-century's head start, and Charles Herbert Moore, Norton's drawing instructor who had himself become a specialist in French medieval architecture. But the Germanic Museum was intended to be more than a counterweight to Harvard's promotion of Europe's Latin culture. Its founder and early supporters also had a different idea of the sort of visual information and aesthetic experience that

should be presented to Harvard students. The Germanic Museum countered Norton's Department of Fine Arts and Moore's Fogg Art Museum (Moore was its first director) with a far broader definition—art without the capital A. The Museum's successive directors and curators have welcomed the "lower" arts of design and understood the value of multifarious archives as well as unique fine-art masterpieces.

And so the Busch-Reisinger Museum is today a very different institution from the Fogg Art Museum, perhaps even a model for its older sibling within the umbrella of the Harvard University Art Museums. Lately, we have seen exhibitions of architecture and design at the Fogg and Sackler museums, and the Fogg has acquired pieces of distinctly vernacular furniture. Has the example of the Wiener Werkstätte and the Bauhaus finally taken hold, now that the Busch-Reisinger collections have moved three blocks south to Werner Otto Hall?

In art history more largely, visual culture has become nearly an equal partner with the study of a canon of masterpieces, and perhaps the example of the Busch-Reisinger Museum (which holds more than its share of masterpieces) should not be overrated. The Museum itself, however, cannot be overrated: within its geographical, cultural mandate; as an environment for the presentation of art; and as a facility for the understanding of art, the Busch-Reisinger Museum has fulfilled the hopes both of its founder and of its supporters here and abroad today. Now, with gratitude to our past and present, we look forward to the next developments, transformations, and successes—the next one hundred years.

Marjorie B. Cohn
Acting Director, Harvard University Art Museums
Carl A. Weyerhaeuser Curator of Prints, Fogg Art Museum

Anniversary Acquisitions:
Chance, Choice, and Opportunity in Building the Collection

Peter Nisbet

How should a museum mark its one-hundredth anniversary? Surely with at least a brief celebratory flourish, if only for having managed to survive so long. The Busch-Reisinger Museum, devoted to promoting the critical understanding and informed appreciation of the arts of the German-speaking countries and the related cultures of Central and Northern Europe, has endured an extraordinarily rich and convoluted history since it opened in a disused Harvard gymnasium in 1903—on November 10, the birthday of both Martin Luther and Friedrich Schiller.

In the course of this history, there must have been more than a few moments when the Museum's continued existence seemed in doubt; the past one hundred years have not offered a historical environment kind to our mission. And the dramatic evolution in our character—from the Germanic Museum focused on photographic and plaster reproductions of sculptural and architectural monuments to an integral partner in the Harvard University Art Museums with an outstanding collection of original artworks in all media and a full array of attendant programs—must raise at least some questions about whether it can even be said that the same institution persisted through these vicissitudes.[1]

Nevertheless, the Busch-Reisinger Museum has managed to persevere and indeed to prove its continuing vitality and productivity as an instrument of teaching and research in the visual arts of Central and Northern Europe. A century of influential and pioneering achievements is an indisputable cause for celebration, perhaps even for a moment of self-congratulation.

But this publication documents a different perspective on the anniversary, one generated by the restless dissatisfaction that must characterize any self-reflective, alert institution. Such an anniversary is an occasion to be especially aware of what remains to be done, to focus on uncompleted tasks and unachieved goals. By creating an opportunity linked to our centennial celebration to enrich the collection with "anniversary acquisitions" (the birthday presents of this volume's title), we acknowledge inadequacies in our holdings and attempt to remedy them.

1. For a detailed introduction to the Museum, see Peter Nisbet and Emilie Norris, comps., *The Busch-Reisinger Museum: History and Holdings* (Cambridge, Mass., 1991). The summary chronology from that volume is reprinted here (pp. 45–54), in a revised and expanded form. For further information on the Museum's trajectory and accomplishments, see my "The Busch-Reisinger Museum in Its Tenth Decade: Reflections on Survival and Success," in James Cuno et al., *Harvard's Art Museums: One Hundred Years of Collecting* (Cambridge, Mass., and New York, 1995), 319–23.

Of course, all museum collections are always inadequate. Between any two objects already in a collection there is necessarily a gap of some kind; once the gap is filled, the resulting three objects produce two new gaps; if filled, there are then four, and so on, ad infinitum. But the obvious absurdity and hopelessness of achieving comprehensiveness (possessing every work of art one might need to teach or research any topic) should not argue against the judicious expansion of a collection, especially if the additions enhance the resonance and depth of works already in the collection. Good works of art seem to demand partners so that stimulating dialogues and interactions can be developed. The artworks selected for this centenary occasion have been assembled in that spirit.

The works in *Birthday Presents* represent the modern period that has come to be the Busch-Reisinger Museum's most active focus. While our acquisition and exhibition efforts by no means exclude art before 1880, it is surely appropriate that the dates of the works in this book more or less match the one hundred years of the Museum's existence. This satisfying chronological range offers at least one work from most of the decades since the Museum was conceived by Kuno Francke in 1897.

However, we acknowledge some arbitrariness and imbalance in this baker's dozen of works. Although the full spectrum of pictorial media (paintings, drawings, prints, photographs) is represented, our commitments to sculpture and to the decorative and applied arts are unfortunately not reflected. Both are traditional concerns of the Museum—sculpture in part because our previous home, Adolphus Busch Hall, seemed particularly well suited to three-dimensional objects, and the applied arts because of the Museum's roots as an almost ethnographic museum of "Germanic culture," with a persistent openness to creativity beyond the traditional fine arts. Similarly, the concentration here on artists from Germany (with one Austrian) is not representative of our cultural reach, which also encompasses Switzerland, the Low Countries, Scandinavia, and parts of Eastern Europe—a mandate defined flexibly and broadly, so as to avoid narrow ethnocentrism or nationalism. And why only one woman?

It is healthy to recognize the chance factors that underpin a celebratory grouping such as this. If some recently acquired works of art had arrived merely a year later, they might have been included as birthday presents and thereby remedied some of these defects. For example, we might have then been able to add a suite of drawings by Hanne Darboven (the gift of Carol and Sol LeWitt, 2001.197) and three 2001 drawings by Sonja Alhäuser (the gift of Melva Bucksbaum, 2001.275–77); a 1977 conceptual photographic work by the Dutchman Jan Dibbets (the gift of Joan and Roger Sonnabend, 2002.46)

and a 1923 chair by his compatriot Gerrit Rietveld (purchased with the Hildegard von Gontard Bequest to the American Friends of the Busch-Reisinger Museum Fund, 2002.48); and a major 1913 wood sculpture by Ernst Barlach (the bequest of Hertha Katz, 2001.52).[2]

Indeed, looking from another perspective, we can speculate about having been able to enhance the diversity and representativeness of our anniversary acquisitions by including works perhaps to be acquired in the near future—say, photographs by Candida Höfer (an acquisition priority) or an as yet unidentified work related to the Bauhaus (to be purchased through the generosity of Werner and Maren Otto in honor of Timotheus R. Pohl). However much the current birthday presents are the result of a focused, concerted effort to attract a responsible and balanced selection of major pieces (and even apparently "minor" ones, but with significance for the work of our Museum), there is a sobering and inevitable element of accident at play.[3] That is surely in the nature of gifts received on any occasion, a serendipity that amounts to an incentive to keep making wish lists with an eye toward future occasions! The dissatisfied restlessness doesn't end.

This group of works, even when dispersed into different places in various galleries and storage areas, will nevertheless forever be united by their association with the Museum's one-hundredth anniversary.[4] That bond will be expressed in credit lines that explicitly acknowledge the occasion for which they were acquired. Will these credit lines exert an influence on a viewer's experience of the works? Certainly, we can imagine that the designation "100th anniversary gift" may prompt the assumption that the work in question is of particular importance. In some cases, this is clearly true, in others less so.[5] But more significant is the credit lines' collective reference to the loyal generosity of the many friends and supporters who have accepted the necessary artificiality of a one-hundredth anniversary and agreed to use it as an occasion for reaffirming their belief in the continuing value of a vigorous and ambitious institution.

Birthday presents prompt thank-you notes, and we are delighted to record our gratitude to all who assisted in this project. Most of all, the newly formed Acquisitions Committee of our European support group, the Friends of the Busch-Reisinger Museum, deserves the highest praise. Under the leadership of Dr. Wilhelm Winterstein, this committee recognized the significance of this moment in the Museum's history and undertook to facilitate some of the most ambitious purchases documented in the following pages. Our thanks to the many individual members of the Friends who participated must be subsumed under our expression of gratitude to the organization's board

2. Information about these works is in the Collections Online searchable database, accessible through the Harvard University Art Museums' website, www.artmuseums. harvard.edu. Of the approximately 17,300 objects in the collection of the Busch-Reisinger Museum, Collections Online offers access to basic information on about 11,150 (i.e., 64%) as of September 2003.
3. It should be added that not all the works acquired as gifts in the immediate lead-up to our anniversary (summer 2002 to summer 2003) were given in honor of the occasion.
4. They will also, of course, remain united in this catalogue, which now joins other publications of collections donated to the Museum, such as James Reibman et al., *The Fredric Wertham Collection: Gift of His Wife Hesketh* (Cambridge, Mass., 1990), and Erika Gemar Költzsch, *German Marks: Postwar Drawings and Prints Donated to the Busch-Reisinger Museum through the German Art Dealers Association* (Cambridge, Mass., 1998), both of which also document relatively unsystematic selections of disparate works of art.
5. The function, history, and effect of the credit line, that ineradicable accompaniment to any display label or photograph caption, have yet to be studied. Some credit lines do surely skew one's experience. (See, for example, the one attached to a drawing of a woman by Gustav Klimt, given anonymously in 1962 to our sister institution, the Fogg Art Museum, "in memory of Marilyn Monroe.") For some thoughts on credit lines, see my "'Gift in Memory of Ernst Teves...' Reflections on a Credit Line," *Harvard University Art Museums Review* 3, no. 1 (Winter 1993–94): 9, 11.

members: Professor Dr. Michael Hoffmann-Becking (chair), James Cuno, Dr. Günter Engler, Carol Johnssen, Renate Küchler, Andreas Langenscheidt, Eberhard Mayntz, Dr. Markus Michalke, and Timotheus R. Pohl.

Our thanks also go out to the individual donors in the United States and beyond who have responded so generously to our undertaking: Barbara Butts and Michael Parke-Taylor, Gabriele Geier, Karin Girke, Leroy and Dorothy Lavine, Timotheus R. Pohl, Carol Selle, Jack Shear and Ellsworth Kelly, and an anonymous benefactor. Some of these names have long figured in the lists of donors of works of art to the Busch-Reisinger Museum, and we very much appreciate this long-term commitment. Several donors willingly agreed that their gifts carry a dual credit line that also acknowledges James Cuno, who announced his resignation as director of the Harvard University Art Museums just as the acquisition of our birthday presents was getting under way. His welcome support of our anniversary project makes these cases of double acknowledgment particularly appropriate.[6] We are also delighted to record in the list of donors the names of two corporations with close associations to the Museum: AXA, which has also been a generous supporter-in-kind of our Friends of the Busch-Reisinger Museum, and DaimlerChrysler, which over fifteen years ago endowed the curatorship of the Museum and has made many other significant contributions.

For advice and guidance, we would like to thank Paulus Deuticke, Dr. Manfred Gentz, Professor Dr. Siegfried Gohr, Dr. Ulrich Guntram, Dr. Eva Mendgen, Elizabeth Nay-Scheibler, Dr. Georg Rheinhardt, Aurel Scheibler, Dr. Hinrich Sieveking, Dr. Katrin Stoll, Walther Storms, Dr. Dietrich von Frank, Dr. Thomas Wessel, and Dr. Renate Wiehager.

The current curatorial staff of the Busch-Reisinger Museum (including Laura Muir, Lisa Lee, Joachim Homann, and Adrian Sudhalter) undertook the challenging task of writing scholarly entries on this diverse group of works, and we are very grateful for their imaginative and invigorating contributions. Production of this handsome volume, made possible by the Art Museums' Andrew W. Mellon Publication Fund, was overseen by Evelyn Rosenthal, head of publications in the Harvard University Art Museums, with careful, sympathetic editing by Carolann Barrett and Marsha Pomerantz and sensitive design by Becky Hunt. Our colleagues in the Department of Imaging and Visual Resources provided high-quality reproductions, often at rather short notice. The complex task of managing the incoming transportation was ably handled by Rachel Vargas of the Registrar's Office. Finally, we thank Marjorie Cohn, acting director of the Harvard University Art Museums, for continuing James Cuno's support of this project and seeing it through to completion.

6. We are pleased to record here the full and impressive list of works of art donated to the Busch-Reisinger Museum in honor of James Cuno: in addition to the works in this catalogue by Emil Nolde, Paula Modersohn-Becker, Oskar Schlemmer, and Hermann Nitsch, the Museum added works by Max Beckmann (a 1917 drypoint, 2003.1), Fritz Winter (a large-scale untitled 1951 gouache on paper, 2002.289), Otto Piene (a 1957/67 painting, 2003.2), and Rudolf de Crignis (a portfolio of three works on card, from 1997, 2002.291), as well as a financial contribution toward the acquisition of a major 1967 oil by Georg Baselitz (2001.51). Details are available in Collections Online (see n. 2).

Birthday Presents

Authors

Joachim Homann

2001–2003 Michalke Curatorial Intern in the Busch-Reisinger Museum

Lisa Lee

Curatorial Assistant in the Busch-Reisinger Museum

Laura Muir

Charles C. Cunningham, Sr., Assistant Curator of the Busch-Reisinger Museum

Peter Nisbet

Daimler-Benz Curator of the Busch-Reisinger Museum

Adrian Sudhalter

2002–2004 Werner and Maren Otto Curatorial Intern in the Busch-Reisinger Museum

EMIL NOLDE

1867 Nolde, Germany | 1956 Seebüll, Germany

Eight Mountain Postcards

c. 1897
Eight photomechanical prints on white wove paper,
approximately 9 x 14 cm (orientation varies)
Gift of Barbara Butts and Michael Parke-Taylor
in honor of James Cuno on the occasion of the
100th Anniversary of the Busch-Reisinger Museum,
2002.290.1–8

1. Jugend 1, no. 36 (1896): 585.
2. Author's translation. Emil Nolde, Das Eigene Leben: Die Zeit der Jugend, 1867–1902, 3rd exp. ed. (Cologne, 1967), 154.
3. For a comprehensive discussion of these postcards, including a list of Nolde's designs, see Manfred Reuther, Das Frühwerk Emil Noldes: Vom Kunstgewerbler zum Künstler (Cologne, 1985), 272–87. Printed information on the Busch-Reisinger's postcards reveals that four postcards (1, 2, 4, 6) were printed in Munich and one (8) in Vienna. The postcards printed in Munich were mailed by an unknown sender to an address in Chicago and are postmarked: "Bremen-New York // 28.7.97."
4. Jugend 2, no. 27 (1897): 464 and Jugend 5, no. 6 (1900): 104.
5. This print is reproduced in Clifford S. Ackley, Timothy O. Benson, and Victor Carlson, Nolde: The Painter's Prints, exh. cat., Museum of Fine Arts, Boston (Boston, 1995), 114.

Emil Nolde's first oil painting, Bergriesen, executed in 1895, depicts a group of giants, personifications of mountain spirits, seated around a rustic table. Nolde had hoped to exhibit this painting, inspired by the Alpine landscape of St. Gall where he lived at the time, at Munich's annual art exhibition of 1895, but the painting was rejected. A more appropriate venue for Nolde's anthropomorphization of nature presented itself in the satirical journal, a genre that peaked in popularity at this time and attracted many of Germany's most innovative artists. In its first year of publication, Munich's premier magazine of this type, Jugend (1896–1940), reproduced two Swiss Postcards (Schweizer Postkarten) by Nolde (then known as Emil Hansen) in color: Jungfrau, Mönch, und Eiger (compare postcard 5) and Fischerhorn, Aletschhorn, Faulberg, und Finsteraarhorn.[1] These humorous images depict Alpine peaks with caricatural faces based on the mountains' vernacular names. According to Nolde's memoirs, these images were so popular that, in order to satisfy the "endless requests made by collectors who desperately wanted to know where they could get them," he arranged to have them published as postcards. "Within ten days," he continues, "one hundred thousand were sold."[2] With the profit from the sale of these postcards, Nolde was able to abandon his teaching post at the Museum for Industry and Craft in St. Gall and move to Munich, where he could commit himself wholeheartedly to becoming an artist.

As far as can be determined, Nolde's mountain postcards were first printed in Munich in the summer of 1897.[3] They were later printed in Vienna, and two more mountain caricatures—Die Mythen–am Vierwaldstättersee and Matterhorn (compare postcard 6)—were reproduced in Jugend in 1897 and 1900.[4] In total, Nolde created over thirty different designs for mountain postcards, for which many original gouache drawings on cardboard survive today in the Nolde Foundation.

Although Nolde's postcards were novelty items created for monetary gain, these visual jokes did not exhaust the potential of the anthropomorphized landscape for the artist. In 1905, in a series of satirical etchings known as Fantasies (Phantasien), Nolde returned to the motif of the mountain faces. In one print from this series, Joy in Life (Lebensfreude), rather than appearing as spectacles for our amusement, the faces seem to sit in judgment of the comical nature-worshipers in their midst—an inverted relationship between viewer and viewed that suggests a self-conscious critique of the very tourist industry Nolde had profited from a few years earlier.[5] Although Nolde would eventually abandon the literal anthropomorphization of nature, the romantic impulse to attribute human feelings to nonhuman subjects would continue to inform his mature landscapes, contributing to their extraordinarily expressive power.

— Adrian Sudhalter

The Beautiful Bernina and the Old Morteratsch (Die schöne Bernina und der alte Morteratsch) [1]
Altmann (Old Man) and Papa Sentis (Altmann und Papa Sentis) [2]
The Seven Electors at the Wallensee and the Alpine Glow (Die sieben Kurfirsten am Wallensee und das Alpenglühen) [3]
The Angry Finsteraarhorn (Finsteraarhorn, das Böse) [4]
Jungfrau (Virgin), Mönch (Monk), and Eiger (Jungfrau, Mönch, und Eiger) [5]
The Matterhorn Smiles (Das Matterhorn lächelt) [6]
The Three Sisters and Alvier at the Valley of the Rhine (Die drei Schwestern und Alvier im Rheintal) [7]
Marmolada, Princess of the Dolomites, Vernel, Her Chancellor, and Rodi di Mulan (Die Dolomitenfürstin Marmolada, Vernel, ihr Reichskanzler, und Rodi di Mulan) [8]

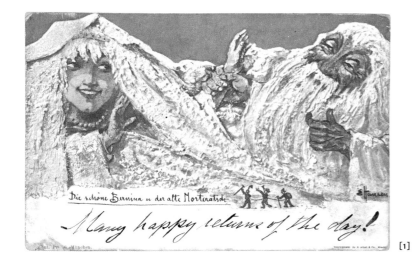

Die schöne Bernina u. der alte Morteratsch

Many happy returns of the day!

F. Ant. Prantl, München.

[1]

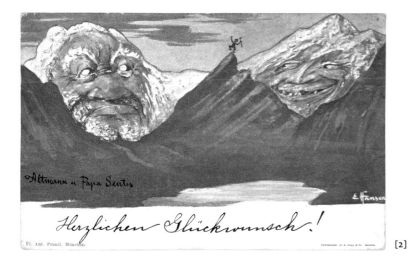

Altmann u. Papa Sentis

Herzlichen Glückwunsch!

Fr. Ant. Prantl, München.

[2]

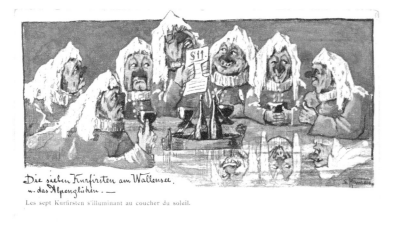

Die sieben Kurfürsten am Wallensee.
u. das Alpenglühen. —

Les sept Kurfürsten s'illuminant au coucher du soleil.

F. A. Prantl, München. 5.

[3]

Finsteraarhorn, das Böse.

Best Wishes!

Fr. Ant. Prantl, München.

[4]

Das Matterhorn lächelt.

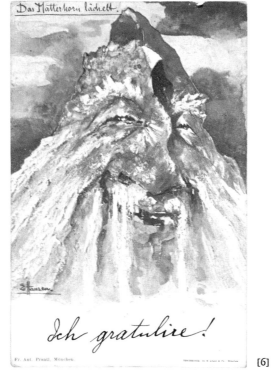

Ich gratulire!

Fr. Ant. Prantl, München.

[6]

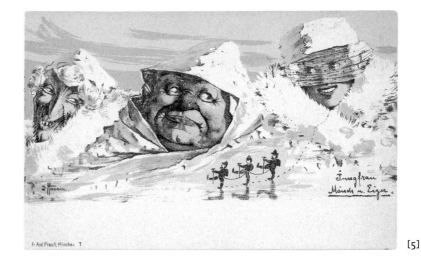

Jungfrau
Mönch u. Eiger

F. Ant Prantl, München 7

[5]

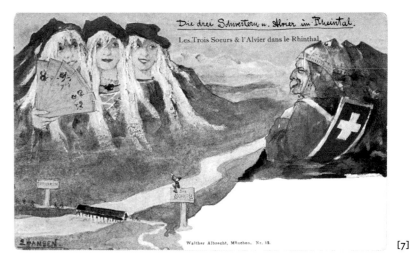

Die drei Schwestern u. Alvier im Rheintal.

Les Trois Soeurs & l'Alvier dans le Rhinthal.

Walther Albrecht, München. Nr. 13.

[7]

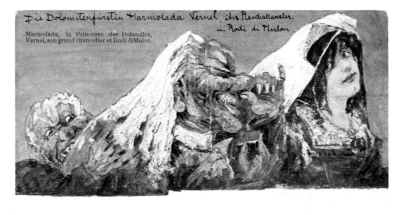

Die Dolomitenfürstin Marmolada Vernel, ihr Reichskanzler.
u. Rodi di Mulon.

Marmolada, la Princesse des Dolomites,
Vernel, son grand chancelier et Rodi di Mulon.

Stern u. Albrecht, München. Nr. 30.

[8]

PAULA MODERSOHN-BECKER

1876 Dresden, Germany | 1907 Worpswede, Germany

Birch Tree in a Landscape
(Zweistämmige Birke vor Landschaft)

1899
Oil on composition board
55.4 x 42.1 cm
Gift of Wilhelm Winterstein through the Acquisitions
Committee of the Friends of the Busch-Reisinger
Museum in honor of James Cuno on the occasion
of the 100th Anniversary of the Museum, 2003.4

In the summer of 1897, Paula Modersohn-Becker arrived at the artists' colony of Worpswede to study painting with Fritz Mackensen (1866–1953). Eight years earlier, Mackensen and Otto Modersohn (1865–1943) had taken up residence in this small rural village fifteen miles northeast of Bremen with the intention of establishing a community of artists insulated from contemporary culture. Drawn to the North German landscape—distinguished by its birch trees, flat topography, and dramatic wide-open skies—the artists aimed to reestablish an essential connection to nature.

Upon her arrival in Worpswede, the twenty-one-year-old Modersohn-Becker immediately recognized that the instruction she would receive from these artists would differ substantially from the academic training she had hitherto experienced in London and Berlin. "Nature," she wrote in her journal, "is supposed to become more important to me than people, to speak more loudly from me. I'm supposed to feel small before its greatness. That's what Mackensen wants. It's the alpha and omega of his criticism."[1]

Modersohn-Becker continued her studies in Berlin during the academic year 1897–98 and returned to Worpswede in the fall of 1898. *Birch Tree in a Landscape* belongs to a series of modestly sized landscapes she painted in Worpswede in 1899.[2] These works, in which the horizon is viewed through one or more trees in the foreground, were all done on cheap composite board. They have the character of oil sketches and may, indeed, have been painted directly from nature. Paint is not built up in layers but is applied directly to the support.

Within the series, *Birch Tree in a Landscape* is the most accomplished and original work. White paint, applied in thick horizontal strokes, describes both the visual and textural qualities of the bark of the birch tree, just as sketchy green and brown strokes describe the tree's fluttering leaves. Long shadows and a yellowish light evoke a late afternoon in autumn. Abandoning the

convention of the picturesque view, Modersohn-Becker places the tree directly in the center of the composition. The tree is not a framing device, as it might have been in a work by Mackensen or Modersohn, but is incontestably the subject of the painting—a living being whose essence is expressed through the dense and lively application of paint. In her journal, Modersohn-Becker wrote: "I wander among the birches. They stand here in their chaste nudity[3] ... delicate, slim, young women who please the eye with their languid, dreamy grace, as if life hadn't unfolded for them yet.... There are also some that are very masculinely bold, with strong straight trunks. They are my 'modern women.'"[4] Whereas in the work of her colleagues, a reverence for nature often led to sentimentalized images, in Modersohn-Becker's work, a search for primitive forces residing within the landscape led to deeply personal and expressive painting.

In 1900, Modersohn-Becker made her first trip (of four) to Paris, where she discovered the work of painters such as Paul Cézanne and Vincent van Gogh. The powerful, new formal syntax introduced by these painters was to deeply influence the artist's work.[5] The development of Modersohn-Becker's formal language, along with her abandonment of landscape painting in favor of human subjects, came to signal an ever widening gap between her work and that of her Worpswede colleagues, among whom she is today the best known.[6] Nevertheless, she continued to live in Worpswede until her premature death in 1907.

—*Adrian Sudhalter*

1. 16 December 1898. This translation is from J. Diane Radycki, *The Letters and Journals of Paula Modersohn-Becker* (Metuchen, N.J., 1980), 83.
2. Compare our work, printed as cat. no. 30, to cat. nos. 31–33 in Günter Busch and Wolfgang Werner, *Paula Modersohn-Becker 1876–1907: Werkverzeichnis der Gemälde* (Munich, 1998), 2:40–41.
3. 15 November 1898. Radycki, *The Letters and Journals*, 77.
4. Summer 1897. Ibid., 32.
5. In a letter to Clara Rilke of 21 October 1907, Modersohn-Becker recalled that Cézanne's work, seen in 1900, "affected me like a thunderstorm." Ibid., 311.
6. For an example of Modersohn-Becker's later work, see the Busch-Reisinger's own *Girl in a Red Dress*, c. 1905 (2000.264) in Busch and Werner, *Paula Modersohn-Becker 1876–1907*, cat. no. 595.

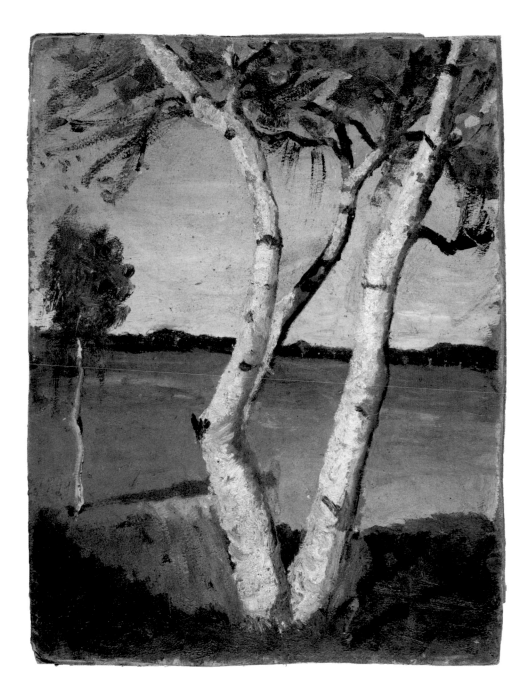

Franz von Stuck

1863 Tettenweis, near Passau, Germany | 1928 Munich, Germany

Wounded Amazon
(Verwundete Amazone)

1905
Oil on canvas
62.8 x 72.7 cm
Purchase through the generosity of the Acquisitions
Committee of the Friends of the Busch-Reisinger
Museum (Rolf Becker, Günther Engler, Andreas
Langenscheidt, Michael Hoffmann-Becking, Carol
Johnssen, Renate Küchler, Karl Wamsler, and
Wilhelm Winterstein) in honor of the 100th
Anniversary of the Museum, 2002.96

1. Otto Julius Bierbaum, for example, had
already associated Stuck's work with the
philosophy of Nietzsche in his Franz Stuck:
Über Hundert Reproduktionen nach Gemälden und
Plastischen Werken, Handzeichnungen und Studien
(Munich, 1893), 58.
2. Wassily Kandinsky, "Reminiscences" (June
1913), in Kenneth C. Lindsay and Peter Vergo,
Kandinsky: Complete Writings on Art (New York,
1994): 376.
3. Eva Mendgen, Franz von Stuck: Die Kunst der
Verführung, exh. cat., Villa Stuck (Tettenweis,
Germany, 2002), 60.
4. I am indebted to Peter Nisbet for this
observation. This self-portrait is reproduced
in Heinrich Voss, Franz von Stuck 1863–1928:
Werkkatalog der Gemälde mit einer Einführung in
seinen Symbolismus (Munich, 1973), 266/359.
5. Two other versions of this composition are
known: a painting of almost the same size
dated 1904 (Van Gogh Museum in Amster-
dam, repr. Voss, Franz von Stuck, 264/201) and
a much larger version dated 1905 (Galerie
Ritthaler, Munich, ibid., 276/202). Stuck
created many preparatory works for this
composition including photographic studies
(repr. Jo-Anne Birnie Danzker et al., Franz von
Stuck und die Photographie: Inszenierung und
Dokumentation, exh. cat., Villa Stuck [Munich,
1996], 25, 64), drawings (repr. Mendgen,
Franz von Stuck, 53, 54), and an oil study (repr.
Voss, Franz von Stuck, 263/200).

Franz von Stuck's Wounded Amazon depicts a battle between amazons and centaurs, an event not found in classical mythology but of the artist's own invention. An almost cinematic progression of the course of battle flows from upper left to lower right, embodied in the figures of three amazons: from the distant spear-throwing amazon in the midst of combat at the upper left; to the large, wounded figure physically turned in on herself at the center; to the cropped foreshortened figure who lies dead, according to her greenish pallor, at the lower right. A single fighting centaur is seen at the upper right. The strong diagonal of the composition is set off against the horizontal thrust of the spear and arrows in the uppermost register and by the bold geometry of the red shield that dominates the painting's middle ground.

Stuck was clearly influenced by the collection of antiquities in Munich's Glyptothek. That institution's Dying Warrior from Aegina informs the pose of Stuck's central amazon just as the Head of Athena provides the source for Stuck's helmet with its distinctive double spiral. Antiquity is also evoked in the friezelike space of the composition. Stuck's modern interpretation of the antique, inspired by Arnold Böcklin (1827–1901) but distinguished by an almost feral sensuality, brought him great success in Munich at the turn of the century. What to some may have appeared gratuitous appeared to others a bold realization of Friedrich Nietzsche's call for the revival of the Dionysian spirit in the fine arts.[1] In addition, for a younger generation of artists it was, above all, Stuck's mastery of the abstract language of form and composition that set him apart from his contemporaries. One of those younger artists, Wassily Kandinsky, who, like Paul Klee and Joseph Albers, studied with Stuck at the Munich Academy around 1900, would later recall that Stuck "advised me to paint initially in black and white, so as to study form itself. He spoke with a surprising affection about art, about the play of forms, about the way forms flow into one another, and won my entire sympathy."[2]

In 1905, the year that Wounded Amazon was painted, Stuck was ennobled, a sign of official recognition bestowed upon an artist who had, ironically, established his reputation in defiance of the academy and been instrumental in founding the Munich Secession. Despite official acclaim, some accused Stuck of redundancy at this point in his career, and a significant shift in the critical reception of his work was marked by the 1904 publication of Julius Meier-Graefe's Die Entwicklungsgeschichte der modernen Kunst, in which painting in the manner of Böcklin was condemned in favor of a more naturalistic alternative.

At least one scholar has suggested that Wounded Amazon might, in fact, be a self-portrait of sorts: an image reflecting the artist's own sense of persecution at the hands of his critics.[3] Beginning with his poster for the first Munich Secession exhibition of 1893, the classical female warrior had served as a symbol for Stuck of the new art he championed. The bronze amazon on horseback in the garden of his self-designed home may even have functioned as a stand-in for the artist himself. This association between painter and amazon is underscored in a self-portrait of 1905 (National Gallery, Berlin), in which Stuck pictures himself in his studio holding a palette and paintbrush—objects that echo the forms of the amazon's own essential trappings, the shield and arrow.[4] A version of Wounded Amazon is clearly discernible in that self-portrait among the paintings visible in the studio behind the artist.

Whether or not we consider Wounded Amazon to be a self-reflective rumination on Stuck's position in the German art world at this transitional moment—1905 was also the year the expressionist group Brücke was founded, in whose wake symbolist and Jugendstil painting appeared instantly outmoded—the fact that he created many preparatory works for this composition and completed at least three versions of this painting may indicate how significant he felt it to be.[5]

—Adrian Sudhalter

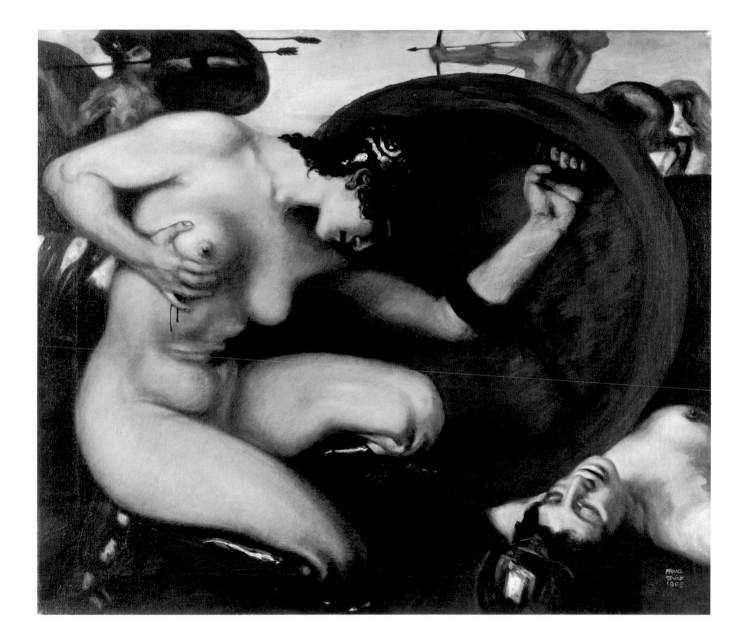

WILLI BAUMEISTER

1889 Stuttgart, Germany | 1955 Stuttgart, Germany

Head
(Kopf)

1920
Oil, graphite, and plaster on canvas
40.3 x 30.5 cm
Gift of DaimlerChrysler in honor of the 100th
Anniversary of the Busch-Reisinger Museum,
2003.125

1. Peter Beye and Felicitas Baumeister, Willi Baumeister: Werkkatalog der Gemälde II (Stuttgart, 2002), 114, cat. no. 256.

2. In a series entitled The Painter (1920–33), Baumeister more extensively treats the theme of the painter's palette and vision, representing the latter as a triangular projection of rainbow color originating from the artist's eye. See Will Grohmann, Willi Baumeister: Life and Work (New York, 1966), 270, cat. nos. 203–18.

3. BR74.8 and BR57.130, respectively. The drawing has been held in trust by the Busch-Reisinger since being deposited at the Museum by Alexander Dorner in 1957.

4. A 1943 drawing in stumped charcoal (BR67.5), a 1949 drawing in stumped charcoal and pastel (1992.99), and a small 1955 painting in oil on composite board (BR56.39).

5. At a conference in 1950, Baumeister defended these ideas in the famous "Darmstadt Conversation" with Hans Sedlmayr and later published his speech as a supplement to subsequent editions of On the Unknown in Art.

At the close of World War I, after four years of military service, Willi Baumeister returned to his native Stuttgart where he resumed studies at the Art Academy. Among the friends he returned to was the artist Oskar Schlemmer, who worked in an adjoining studio at the academy, and the architects Richard Döcker and Gustav Schleicher. In addition to forming friendships with these young architects, Baumeister drew inspiration from their working methods and from the new clarity and objectivity of modernist designs, which had developed out of a reaction to the destruction and chaos of the war. In his own work, the concept of the plane assumed primary importance along with his interest in finding ways to incorporate art into the modernist building. Although never officially affiliated with the Bauhaus, which opened in 1919, Baumeister was drawn to its progressive program, which sought to unite painting, sculpture, and architecture.

This work is part of a series of heads that Baumeister began in 1919.[1] Returning to a theme he had begun to address prior to his departure in 1914 for the war, the new series took the simplification of those earlier heads a step further, eliminating any hint of naturalism and replacing it with a machinelike vocabulary of geometric planes. The artist also began to incorporate relief elements of plaster, sand, and putty into his work. Here, a rectangular plaster block serves as a pedestal for the head but also refers back to the wall on which it hangs, a concept more elaborately explored in his Wall Paintings (1919–23), relief panels intended to be inserted directly into the wall.

In addition to working with actual building materials, Baumeister employed the diagrammatic language of architectural plans. In this work, he provides both exterior and interior views of his subject. The right side, accompanied by schematic notations in graphite, reveals the head's internal structure and details like a blueprint. The opaque left side suggests that it sees the external world through a set of multicolored lenses. Equipped with this machine-age alternative to the traditional painter's palette, the artist has merely to open his eye in order to project a spectrum of vibrant color onto the world.[2] Although not identified as such, this work might be seen as a kind of self-portrait in which Baumeister presents himself as an artist who thinks like an architect but uses the tools of a painter. Appropriately, the first owner of this work was the architect and painter Gustav Schleicher, with whom Baumeister occasionally shared ideas about art.

This is the earliest work by Baumeister to enter the Busch-Reisinger Museum's collection and one of only a few surviving examples from the Head series. It joins two other early figure studies: a lithograph, Abstract Seated Figure (c. 1921), and a gouache and graphite drawing, Apollo with Seated Figure (c. 1922).[3] Three later works[4] in the Busch-Reisinger Museum illustrate his turn toward archaic imagery and abstraction in the years following his dismissal by the Nazis from his teaching position in Frankfurt in 1933. These subjects were among the principal topics treated in his book On the Unknown in Art, which was published in 1947 and positioned Baumeister in the postwar years as one of abstract painting's chief proponents and defenders.[5]

In 1946, Baumeister returned to the Stuttgart Art Academy as a professor forty years after he had first enrolled as a student. As a living link to the avant-garde past, he was regarded as a kind of father of modern art who, through his ongoing work as a teacher, theorist, and artist, continued to play an active and influential role in the modern art movement in Germany until his death in 1955.

—Laura Muir

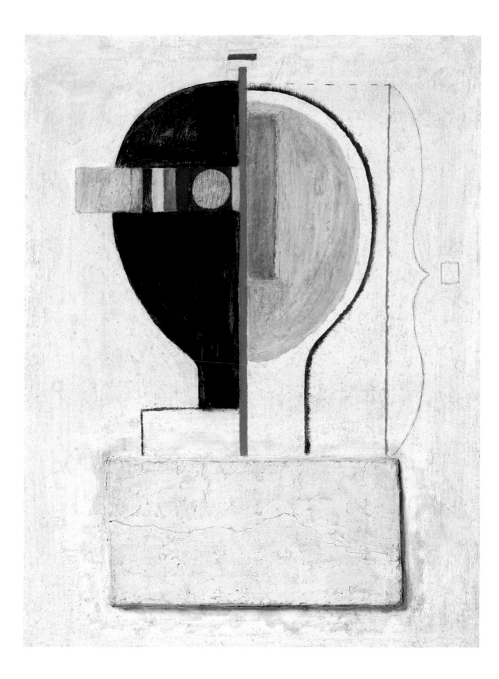

Oskar Schlemmer

1888 Stuttgart, Germany | 1943 Baden-Baden, Germany

Small Picture VI: Blue Man, Diagonally
(Kleinbild VI: Blauer Schräg)

1932
Oil over graphite on paper, mounted on board
10.6 x 23 cm
Promised gift of Timotheus R. Pohl in honor of
James Cuno on the occasion of the 100th Anniversary
of the Busch-Reisinger Museum, TL38555

1. Peter Nisbet, *Oskar Schlemmer*, exh. review, Baltimore Museum of Art, in *Art Journal* 46, no. 2 (Summer 1987): 149–53.
2. "Wieder einfach werden." Karin von Maur, *Oskar Schlemmer* (herausgegeben vom Oskar Schlemmer Archiv der Staatsgalerie Stuttgart) (Munich, 1979), 212. This work is no. G261 in Karin von Maur's catalogue raisonné of Schlemmer's works, *Oskar Schlemmer: Oeuvrekatalog der Gemälde, Aquarelle, Pastelle, und Plastiken* (Munich, 1979).
3. Nancy Troy, "The Art of Reconciliation: Oskar Schlemmer's Work for the Theater," in Arnold Lehman and Brenda Richardson, eds., *Oskar Schlemmer*, exh. cat., Baltimore Museum of Art (Baltimore, 1986), 144–45.
4. Heimo Kuchling, ed., *Oskar Schlemmer: Der Mensch. Unterricht am Bauhaus (nachgelassene Aufzeichnungen)* (Mainz, Germany, 1969).
5. In November 1930, Schlemmer explained in a radio interview, "[I want] to show the presence of human beings without exuberance, without drama, without telling a story!" von Maur, *Oskar Schlemmer*, 194.

Oskar Schlemmer never crossed the Atlantic and did not actively participate in the promotion of the Bauhaus spirit in the United States. Nonetheless, he is credited with the iconic image of the Dessau-based school for art and design, the widely known *Bauhaus Stairway* (The Museum of Modern Art, New York). Executed in 1932, both *Bauhaus Stairway* and *Blue Man, Diagonally* were painted in a retrospective mood: in 1929 the painter, sculptor, choreographer, dancer, and stage designer had left the Bauhaus, where he had headed the theater workshop, to teach at the Fine Arts Academy in Breslau (Wroclaw), Silesia. There, he received news of the closing of the Bauhaus-Dessau in 1932 due to political pressure. His own teaching appointment ended not much later, when the Breslau academy stopped all activities during the global financial crisis.

At the high point of his Bauhaus stage work, the artist had abandoned the pictorial arts for years, but he now returned to painting because it offered the freedom to work without the many prerequisites of theatrical productions.[1] Schlemmer's multifaceted painterly oeuvre culminated in complex compositions of figures in perspectival spaces such as the *Bauhaus Stairway*. In parallel, he investigated in a series of small paintings the visual elements on which his art was based. Among these, *Blue Man, Diagonally* stands out as the consequence of a process of formal reduction, which Schlemmer characterized in June 1931 as "becoming simple again."[2]

The dynamic balance Schlemmer found in *Blue Man, Diagonally* choreographs the viewer's gaze. Spanning the horizontal field, the arm and head seem to bar entry into the pictorial space. The bent and raised body-forms become a triangle, with a deep blue base bolstered by reddish and yellowish colors in the hand and face. While the figurative gesture seems to distance the image from the viewer, the texture of the paint on glossy paper gives it an immediate presence. Schlemmer applies the oil colors not only with a brush—and partly overworks them with solvent—

but uses his fingers as well. His fingerprints give a tactile appearance to the face.

Schlemmer, an artist who often armed himself with theories as rigid as the costumes he created for dancing, referred in this painting to the understanding of color developed at the Bauhaus. Blue represented passivity and self-absorption. In a 1927 *Form Dance*, a blue dancer performed slow and heavy movements before resting on a bench, one arm holding the torso at an angle of 150 degrees.[3] Here, as in many of his theatrical and painterly works, Schlemmer was expressing the well-ordered human form in all its functions, motions, and gestures. This pedagogical impulse also manifested itself in courses he taught entitled *Man* (Dessau, 1928–29) and *Man and Space* (Breslau, 1930–31), which addressed wide-ranging artistic, philosophical, and psychological topics.[4] The classes centered on the study of the human figure, and students regularly posed as models for classmates. Schlemmer guided them to see themselves in relation to one another and to the order defining the world around them: he taught that humans are cosmic entities. Nevertheless, with *Blue Man, Diagonally*, the artist reassured himself that at the core of his artistic universe was a space—impenetrable, safe, but not isolated—reserved for pure being.[5]

—Joachim Homann

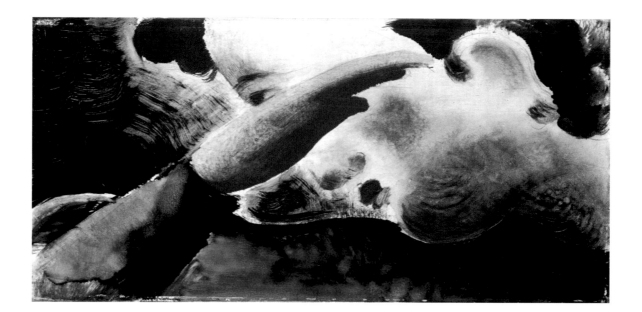

Karl Schmidt-Rottluff

1884 Rottluff near Chemnitz, Germany | 1976 West Berlin, Germany

The White Cloud
(Die weisse Wolke)

1936
Watercolor and black ink on off-white wove paper
50 x 69.3 cm
Gift of Gabriele Geier on the occasion of the 100th
Anniversary of the Busch-Reisinger Museum,
2003.35

Karl Schmidt-Rottluff created this work during the summer of 1936 near the small fishing village of Rumbke between Lake Leba (Lebasee) and the Baltic Sea.[1] During the summers he spent in this remote spot in northern Germany (now Poland) along the Pomeranian coast (1932–43), he often worked in watercolor with the unpopulated natural landscape as his primary theme. Here he translates the water, shore, mountain range, and sky into a series of flat horizontal bands, first sketched in black ink and then filled in with washes of color. The Revekol, the region's most dramatic geographic landmark and a recurring motif in Schmidt-Rottluff's Lebasee pictures, appears as a slight swell on the horizon. In contrast with the expressive angularity and strident colors of his earlier work and characteristic of the gentler style he had adopted in the mid-1920s, his lines here are soft and fluid, his forms simplified, and his colors soothing.

Deserted and silent beneath a large white cloud, the landscape seems to convey the isolation as well as the sanctuary Schmidt-Rottluff found in this "marvelously lonely" place.[2] But he may also have wished to communicate something slightly less obvious. Although the former Brücke artist had long sought refuge in nature, in these years his retreat was more an exile imposed by the National Socialists' growing hostility toward the avant-garde, which in 1933 had resulted in Schmidt-Rottluff's expulsion from the Prussian Academy of Art. While the artist's turn toward a "neutral" subject matter and a less overtly expressionist style might be interpreted as an act of self-preservation or even compliance, his impossibly serene landscapes might also be seen as subtle acts of resistance. In this work, the utter stillness, glassy water, and abandoned canoes are finally unnerving, making the picture seem less a straightforward reflection of the artist's immediate situation than an eerie warning of the crisis to come.

In the spring of 1937, Schmidt-Rottluff's watercolors were exhibited at the Karl Buchholz Gallery in Berlin, but by summer it had become illegal to show his work, and fifty-one of his paintings and prints were seized by the Nazis from German museums for the *Degenerate Art* exhibition, which opened in Munich in July. The following year, an additional 608 of his works were confiscated from public collections. In spite of these difficulties, Schmidt-Rottluff remained in Germany during the war, returning for several extended stays to the seclusion of Pomerania where he continued to paint despite having been officially banned from it in 1941.

The White Cloud enhances the Busch-Reisinger Museum's collection of early-twentieth-century watercolors, including works by Schmidt-Rottluff's friends and contemporaries Emil Nolde, Lyonel Feininger, and others. It also broadens the Museum's holdings of the artist's own work, which, until now, included paintings, drawings, and prints but none of the later landscapes, so handsomely represented in this work.

—Laura Muir

1. The dating of this work is based on the circled inscription "3651," which appears in graphite in the lower right corner of the sheet. In the numbering system Schmidt-Rottluff employed for his watercolors between 1932 and 1939, the first two digits indicate the year of creation and are followed by the work's sequential number.
2. "Hier ist es fabelhaft einsam—zwischen Lebasee und Ostsee gelegen—eine außerordentliche Dünenlandschaft, ich möchte sagen—großartiger als auf der Kurischen Nehrung." Letter of 28 June 1932 to F. Schreiber-Weigand, quoted in Magdalena M. Moeller and Hans-Werner Schmidt, *Karl Schmidt-Rottluff—Der Maler*, exh. cat., Städtische Kunsthalle Düsseldorf, Städtische Kunstsammlungen Chemnitz, Brücke Museum (Stuttgart, 1992), 264.

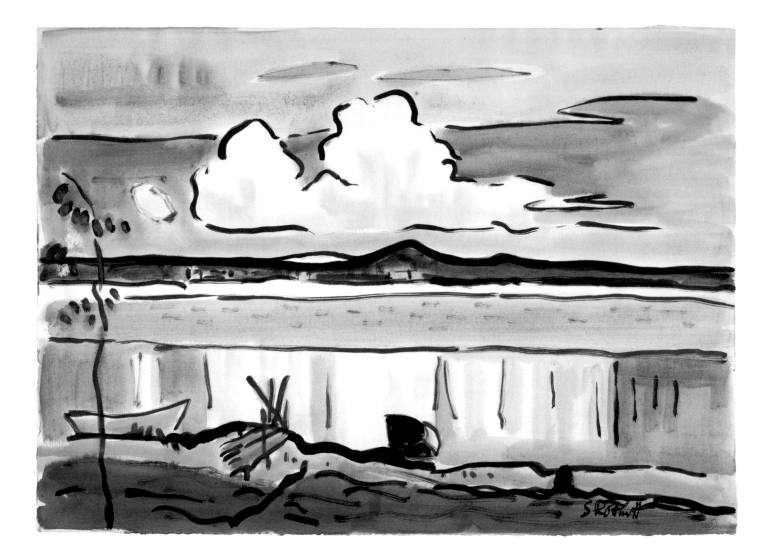

RAIMUND GIRKE

1930 Heinzendorf (Silesia), Germany | 2002 Cologne, Germany

Structures
(Strukturen)

1959
Synthetic resin (polyvinyl acetate emulsion)
on canvas
120 x 181.4 cm
Gift of Karin Girke on the occasion of the 100th
Anniversary of the Busch-Reisinger Museum,
2003.62

1. The Busch-Reisinger Museum owns two late works on paper of 1990 by Girke (1992.140, 1992.141), one of which deploys interlacing and alternating strokes of white and blue-gray on a dark ground. See the discussion, with recommendations for further reading about Girke's oeuvre, in Erika Gemar Költzsch, *German Marks: Postwar Drawings and Prints Donated to the Busch-Reisinger Museum through the German Art Dealers Association* (Cambridge, Mass., 1998), cat. nos. 86 and 87, pp. 134–35, and color plate p. 29.
2. *Monochrome Malerei*, exh. cat., Städtisches Museum Schloß Morsbroich (Leverkusen, Germany, 1960), 6. *Structures* was Girke's only work in the exhibition (cat. no. 32, p. 47 [as *Komposition*, lent by the Galerie Seide, Hannover]; also illustrated in black and white, p. 40). The exhibition, organized by Udo Kultermann and presented 18 March– 8 May 1960, included a very wide range of work by thirty painters, including Piero Dorazio, Lucio Fontana, Rupprecht Geiger, Yves Klein, Piero Manzoni, Arnulf Rainer, and Mark Rothko. Girke's statement "Thoughts on My Pictures" is quoted and translated by the present author from Raimund Girke, *Texte, 1960–1995* (Zug, Switzerland, 1995), n.p.

As did many German, European, and indeed American painters of his generation, Raimund Girke experienced the end of the 1950s as a period when the transcendental claims made about gestural abstraction—as an inherently authentic, expressive subjectivity—came to seem exhausted and discredited. He and many of his contemporaries reacted by committing to a practice that emphasized objectivity, regularity, and an engagement with the materials and methods of painting. For Girke, this meant a career focused largely on monochrome painting—predominantly whites, with some gray, and, in the dozen or so years before his untimely death, an emergence of blues and browns—applied to surfaces in a developing variety of emphatic and noticeable strokes.[1]

Structures is a key work from the early stages of that trajectory. It was included in a seminal group exhibition, *Monochrome Malerei* (*Monochrome Painting*), held in Leverkusen, Germany, in 1960, and the artist's statement in the exhibition catalogue elucidates the stance behind this work.[2] After explaining that the concentration on one color allows it to emerge in its full intensity and authority, Girke writes of his subsequent steps:

> I abandoned the use of multiple colors in favor of one single color, and, with logical consequence, I have in turn abandoned this one color in favor of the uncolorful color of black-white-gray.

> Black-white-gray as a color range is as yet to a large extent unexplored, full of secrets and adventures.

> Black-white-gray becomes color ... only when I push black in the subtlest increments through innumerable gray variations to white, the color that outshines everything else, only when the color surface is set into motion through the continual alteration in the light-dark.

> *White*—cold and heat simultaneously—embodiment of the pure, the bright, the clear.

Black and gray have a subordinate function. Their job is to put white into a subtle vibration, with the help of the structure to transmit a continuous movement to it across the entire pictorial surface, to modulate it sensitively, and, as the support of the white, to bring it to its full-strength radiance. Black and gray underscore white as its counterparts and intensify its luminosity.

Composition in the traditional sense no longer exists. The entire picture is one structural field. While the field is indeed divided into individual structural areas, no dominant formal elements appear in it. The various structural areas consist of innumerable, only slightly varying, structural elements, all virtually identical in tone, form, and size, which give the paint surface a quiet but extremely compelling life. Every structural element, no matter how small, has its function as part of the entire structural field, is active, and therefore essential. Various orientational values of the individual structural areas call attention to themselves and then are covered over again in mutual interpenetration and transparent layering.

Within narrowly defined borders, the world of the monochrome offers inexhaustible possibilities of a wholly new type. Limited to itself alone, color is freed of all fetters, achieves its own life, and reveals itself now in its full power.

—*Peter Nisbet*

ERNST WILHELM NAY

1902 Berlin, Germany | 1968 Cologne, Germany

Seraphim

1964
Oil on canvas
162 x 150.7 cm
Gift of the Acquisitions Committee of the Friends
of the Busch-Reisinger Museum on the occasion
of the 100th Anniversary of the Museum, 2003.64

1. See *E. W. Nay: A Retrospective* (Cologne, 1990), 128. In subsequent showings of the three paintings, this radical form of presentation was not repeated. The history of using the ceiling to display modernist nonrepresentational paintings is surprisingly thin. If the curator was responsible for the experiment with Nay in 1964, it was the dealer Sidney Janis who had shown paintings by Jackson Pollock on the ceiling of his 1955 exhibition, apparently for lack of space on the walls. See Steven Naifeh and Gregory White Smith, *Jackson Pollock: An American Saga* (New York, 1989), 752.
2. Consider the following, from 1963: *Starlight, Morningstar, Orbit, Stars,* and *Firmament.* Many other titles refer more neutrally to color choices or, more resonantly, to light and fire. See Aurel Scheibler, *Ernst Wilhelm Nay: Werkverzeichnis der Gemälde,* 2 vols. (Cologne, 1990).
3. The painting is cat. no. 1100 in ibid.
4. The Busch-Reisinger Museum owns a fine example of this style—a watercolor of 1957 (BR57.31)—which brought the artist international attention and renown.
5. These forms can be seen in a 1946 drawing of a crouching woman and child in the collection of the Museum (1992.192). For an analysis of this drawing, see Erika Gemar Költzsch, *German Marks: Postwar Drawings and Prints Donated to the Busch-Reisinger Museum through the German Art Dealers Association* (Cambridge, Mass., 1998), cat. no. 69, pp. 116–17. A 1949 gouache in the Museum's collection, *Leda and the Swan* (BR62.227), shares many of the characteristics of the "Hecate pictures" as well as of the subsequent, more planar "fugal pictures."

In 1964, paintings by Ernst Wilhelm Nay were included in *Documenta III* in Kassel. In an innovative and controversial installation, organizer Arnold Bode hung three very large square canvases at staggered angles in a row on the ceiling, creating a canopylike vault of Nay's energetic, dynamic abstractions.[1] The placement not only reflected the experimentalism of the era but must surely also have seemed suitable for the work of an artist who in those years regularly used titles referring to astronomy and the skies.[2] Looking up was an appropriate attitude.

Seraphim, the title of the Busch-Reisinger Museum's painting from the *Documenta* year,[3] also carries heavenly associations, evoking the highest order in the hierarchy of angels in Christian theology. While the viewer should certainly resist the temptation to see Nay's sweeping circular forms as illustrative echoes of bi-winged angels standing in the presence of God, the five boldly brushed partial or complete discs do attend the radiant yellow center in a powerful composition full of spontaneous and vibrant energy.

Divine or interstellar space is infinite, that is, dimensionless and without perspective. Nay was deeply concerned with an analogous painterly space and with choreographing rhythms of color on a planar surface. With his transition in the mid-1950s to his "disc pictures," Nay deployed circles of varying sizes and hues and eliminated all figural references.[4] By the early 1960s, these discs began to be troubled by gestural erasures, broken strokes, and the emergence of a disturbing iconographic element, an eye form created by lenslike lines surrounding a central circle. In their visual intensity, Nay's "eye pictures" of 1963–65 (including *Seraphim*) thereby both exalt and thematize vision.

The use of this kind of legible sign refers us back to earlier stages in Nay's long career, which had begun in earnest in the late 1920s. In the 1940s, Nay had developed an idiosyncratic style, blending cubist disintegration with expressionist color to depict human or mythological figures. The prominent eyes, navels, and bellies in his "Hecate pictures" were often rendered in the schematic circles and ovals that then reemerged as disembodied icons around the time of *Seraphim.*[5] This confident and masterful moment in Nay's career, coinciding with his success at *Documenta* and a significant gallery exhibition in New York, prompted at least two U.S. museums (the Wadsworth Atheneum and the Albright-Knox Art Gallery) to acquire paintings of 1964. The final phase of Nay's artistic trajectory, the years between 1965 and 1968, saw a radical flattening, clarification, and simplification of forms—a summation of a lifetime's engagement with the formal and emotional power of color.

—Peter Nisbet

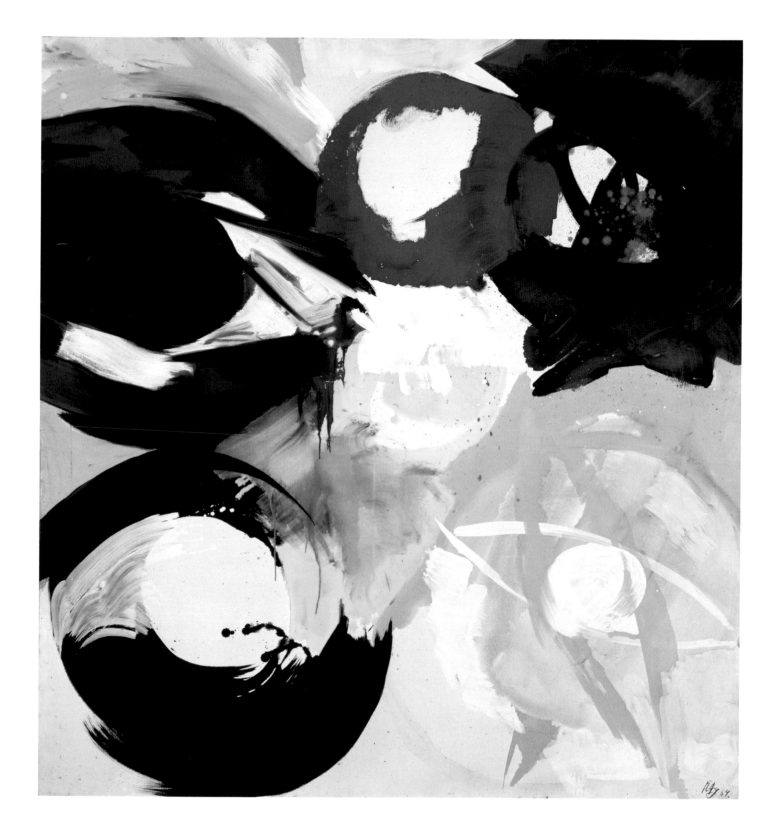

KLAUS RINKE

1939 Wattenscheid, Germany

Horizontal Water Jet—Directed against a
Window from the Outside
(Waagerechter Wasserstrahl—Von außen
gegen ein Fenster gerichtet)

1969
Two gelatin silver prints
59.1 x 84.3 cm
Gift of Carol O. Selle on the occasion of the 100th
Anniversary of the Busch-Reisinger Museum,
2003.61

1. "Klaus Rinke: Interview with Georg Jappe,"
Studio International 192, no. 982 (July/August
1976): 64.
2. *Twelve Barrels of Ladled Rhine Water* (1969)
was first presented in the exhibition *14 x 14.
Eskalation*, Staatliche Kunsthalle, Baden-
Baden, 6 June–20 July 1969.
3. "Der Versuch, die Gegenwart eines Flusses
Vergangenheit werden zu lassen." Klaus
Rinke, *Klaus Rinke*, exh. cat., Städtisches
Museum Schloß Morsbroich (Leverkusen,
Germany, 1970).
4. Klaus Rinke, *Klaus Rinke (1954–1991)
Retroaktiv: Werkverzeichnis 1954–1991 der
Malerei, Skulptur, Primärdemonstrationen,
Fotografie und Zeichnungen ab 1980*, exh. cat.,
Kunsthalle Düsseldorf (Düsseldorf, 1992),
118–19. A hose, nozzle, and stand, as well as
photographs from a subsequent presentation
of this action, are in the Hahn Collection of
the Museum of Modern Art, Vienna.
5. *Diversion—A River Pumped through a Museum*
was presented in the exhibition *14 x 14.
Eskalation. Vertical Water Jet* was first presented
in the exhibition *Intermedia 69*, Heidelberg,
16 May–22 June 1969.
6. "Interview between Karin Thomas and
Klaus Rinke, at Cologne, September 4th,
1972," in *Klaus Rinke, Zeit, Raum, Körper,
Handlungen* (Cologne, 1972), 20.

In the fall of 1957, while still an art student at the Folkwang-Schule in Essen, Klaus Rinke traveled to Norway on an iron-ore ship and experienced the ocean for the first time. He was impressed by its vastness and sheer power, by the towering waves that made the massive freighter feel like "nothing at all," and became newly conscious of water as an element.[1] By the late 1960s, it would become his primary artistic material after he concluded that painting did not correspond to real life and was thus an inadequate vehicle for his art. Rinke was interested in elucidating fundamental aspects of existence, to which he believed people had increasingly become oblivious. The passage of time and the force of gravity became his particular concerns, and in water he found a very specific means for describing them, using it not as a symbolic material but as a sculptural one. His work with water often took the form of actions or demonstrations that introduced his own body into the art.

In one of Rinke's earliest and best known actions, he ladled water from twelve locations along the Rhine between Düsseldorf and Baden-Baden into twelve metal barrels, which he then delivered to the Kunsthalle in Baden-Baden where they were exhibited with the ladle.[2] As was common practice in the late 1960s and early 1970s among artists whose work took the form of actions or performances, the entire process was filmed and photographed. In subsequent installations, the barrels of water and the ladle were accompanied by framed photographs of Rinke collecting water at each site, which reinforced his notion that the work was "an attempt to convert a river from present to past."[3]

A few months later, Rinke presented *Horizontal Water Jet—Directed against a Window from the Outside* in the courtyard of the Munich exhibitions space Aktionsraum 1 as part of the exhibition *Klaus Rinke: Eröffnungsaktion* (18–19 October 1969).[4] This action, which is the subject of the two photographs here, combined elements from demonstrations he had presented earlier that year in which he, in one, circulated water through a museum in clear hoses and, in another, set it free in the form of a powerful vertical water jet.[5] His use of the window in this action allowed him to see the impact of the water but also provided a definite conclusion to the demonstration's narrative by literally stopping its trajectory. As Rinke has said, when the element of time is introduced, "gradually, art is transformed into process,"[6] and the story of this process—of water being delivered by a hose, expelled in a thin stream, and then finally splintering against the windowpane—is told through the photographs.

In addition to exemplifying the action's themes of containment and release, the two photographs allow the viewer to watch as three dimensions (the water jet) are transformed into two (the pattern on the windowpane), as banal representation becomes abstraction. In bringing together two such radically different types of images (although both are in fact straight documentary photographs), Rinke seems to ponder two ways of approaching art. This work may represent an attempt to reconcile those two tendencies, but it may also reveal a longing for the abstract painting he had abandoned in favor of action- and process-based art. Here the hose and water in effect become his brush and ink and the windowpane his picture surface as he takes the traditional idea of a picture plane as a window onto the world to its literal extreme, yet denies the view onto the world with the water. In the early 1970s, Rinke began a series of graphite drawings in which fine lines radiate out from a central point, recreating by hand what the water had inscribed on the glass and the camera had frozen. Although water remained Rinke's primary material, it may also have provided a means of finding his way back to traditional media, perhaps with a new understanding of the elemental forces that first prompted his investigations.

—Laura Muir

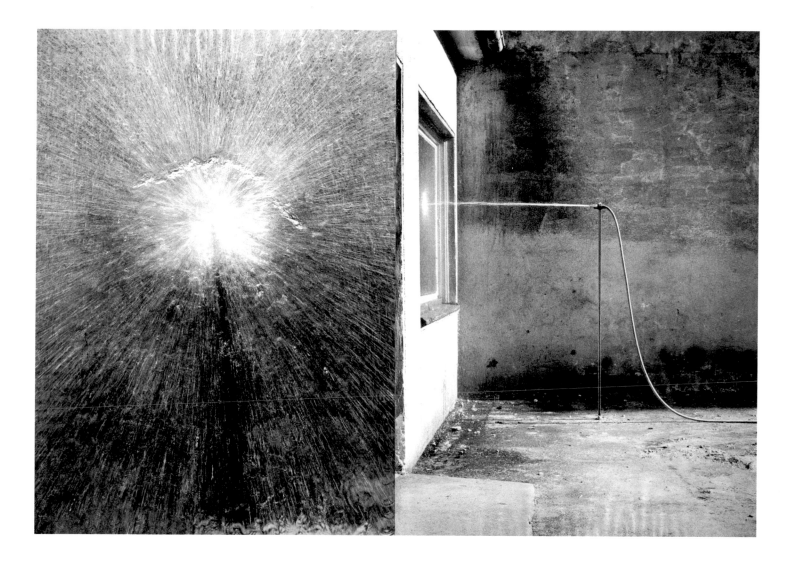

HERMANN NITSCH

1938 Vienna, Austria

The Last Supper
(Das letzte Abendmahl)

1986
Colored crayon over screenprint on blood-stained cotton
164 x 390 cm
Gift of Jack Shear and Ellsworth Kelly in honor of James Cuno on the occasion of the 100th Anniversary of the Busch-Reisinger Museum, 2003.3

1. For a discussion of the O. M. Theatre and Viennese actionism, see Hubert Klocker, *Wiener Aktionismus, Wien, 1960–1971: Der zertrümmerte Spiegel: Günter Brus, Otto Mühl, Hermann Nitsch, Rudolf Schwarzkogler* (Klagenfurt, Austria, 1989), 46–48, 51, 102–4.
2. The Last Supper and the sacrifice of Dionysus are numbers 1 and 4, respectively, in a list of leitmotifs of the O. M. Theatre laid out in the "O. M. Theatre Manifesto," reprinted in *Brus, Mühl, Nitsch, Schwarzkogler: Writings of the Vienna Actionists*, ed. Malcolm Green (London, 1999), 140–41.
3. The presence of blood has been confirmed by Glenn Gates, Straus Center for Conservation, through analysis of FT-IR data collected from a sample.
4. Klocker, *Wiener Aktionismus*, 267.
5. Hermann Nitsch, *The Architecture of the O. M. Theatre* (Munich, 1987), 1:26.
6. Transcribed and translated by Adrian Sudhalter and Andreas Huebener.
7. These include editions of eighty, eighteen, and twenty-five—of which the latter two are hand-reworked. An additional, unreworked edition of thirty-six is of uncertain issue date. Information about the editions was determined in a search of auctions on www.artnet.com on 6 June 2003.

The Orgies-Mysteries Theatre, or O. M. Theatre, is the rubric under which Hermann Nitsch has approached the concept of the total work of art, or *Gesamtkunstwerk*.[1] Formulated in 1957, elaborated in the 1960s when Nitsch was a cofounder and proponent of Viennese actionism, and sustained in the decades since the dissolution of the actionists in 1970, the O. M. Theatre encompasses actions, dramas, paintings, and festivals by the artist and is bolstered by work in the graphic arts, such as *The Last Supper*. Nitsch's varied output is unified through a repetition of motifs and references deployed in a coherent pictorial language and dramaturgy. In *The Last Supper*, he treats in characteristically monumental scale two long-standing themes of the O. M. Theatre: a hybridization of Christian and Dionysian narratives, and a site plan for an underground city.

Christ and Dionysus often appear in Nitsch's work as a single tragic figure whose sacrificial death is repeated and unresolved. The transubstantiated elements of the Eucharist are the body and blood of Christ; the frenzied maenads rend and devour a wild beast representing Dionysus; in both cases, the consumption of a deity leads to transcendence.[2] The intermingling of references in *The Last Supper* parallels the layering of the media: hand-drawn skeins lie atop a screenprint executed on a blood-stained cloth remnant of an action.[3] Allusions to Leonardo da Vinci's anatomical studies, notebook sketches, and fresco of the Last Supper are similarly spliced and collaged.

In 1965, Nitsch executed the first versions of a subterranean site for his actions and dramas.[4] Many drawn and printed conceptual plans have followed. Their aesthetic conflates the architectural with the organic: globular chambers and a profusion of corridors form architectural viscera, metaphorical bowels. Indeed, the artist writes, "The manneristic expansion of my theatre project makes it conceivable that my happenings could take place within an architecture of not only single organs, but of the whole human body transformed into rooms."[5] Flayed and

dissected in *The Last Supper*, the bodies of Christ and his disciples are deconstructed even as they are consumed by architectural construction. The architectural aspect of Nitsch's renderings, rather than the conceptual aspect, is more evident in a delicate drawing in the collection of the Fogg Art Museum. In this untitled work, nine sheets of paper, like abutting plot plans, form the image surface on which the drawn concentric rectangles read as fortifications.

The narrative of the making of *The Last Supper* is printed at the upper right: "entwurf einer unterirdischen stadt nach dem bilde des letzten abendmahles für das aktionsdrama *die zerstörung und wiederentstehung unseres weltalls*" (design for a subterranean city based upon the picture of the Last Supper for the action-drama *the destruction and reconstruction of our universe*).[6] At the lower right, Nitsch explains that the screenprint is based on a drawing from 1976–79. In 1977, the death of the artist's wife, Beate Nitsch, in an automobile accident, caused him to halt progress on the nearly completed drawing. Nitsch took up the unfinished drawing in 1978 and finished it in order to reproduce it as a print.

In 1983, at least three editions of the print were issued.[7] Nitsch's extensive and complex hand-reworking of the Busch-Reisinger Museum's unique version took place in 1986.

—Lisa Lee

GÜNTER UMBERG

1942 Bonn, Germany

Untitled
(Ohne Titel)

1989
Pigment and dammar on aluminum
142.2 x 150.3 cm (irregular)
Gift of Leroy and Dorothy Lavine on the occasion
of the 100th Anniversary of the Busch-Reisinger
Museum, 2003.36

Günter Umberg's paintings take time, to see and to make. The viewer's efforts at perception match the artist's work on the picture and the pictured color. Both forms of labor are intensive accumulations of experience, visual and bodily. Both engage the self.

The dense, deep, rigorously nonfigurative surfaces of Umberg's paintings result from his repeated application of several dozen layers of dark, dry, mostly matte pigments, interspersed after every paint layer with a clear binding material (dammar), which leaves no trace. The material is arduously built up on nonabsorbent, untextured supports (usually rectangular or near-rectangular in format), with flat aluminum sheets set against the wall and beveled wood panels raising the color surface away from it. This painting on aluminum, the second by Umberg to enter the collection of the Busch-Reisinger Museum,[1] is one of a group that are among the largest produced by the artist.[2]

The attentive viewer engages this painted black surface, experiencing the picture somewhere between its granular physicality and its elusive spatiality. Distance, both actual and aesthetic, ensures that the color surface points beyond material (it must never be touched), while closeness closes off the possibility of seeing the dark form exclusively as an absence of light. The comfortable scale and careful placement of the picture on the wall enable a face-to-face dialogue between the individual viewer and individual painting, position and "opposition." In this sense, Umberg's paintings take space. They activate and occupy their settings.[3] The slight, irritating irregularity of format strengthens the picture's refusal to submit to the constraints of the space in which it is shown.

The specifics of surface and situation in Umberg's paintings set impressively high hurdles against any casual attitude. The owner or custodian of these paintings is obligated to extraordinary care in their handling, and virtually nothing of the experience of the work can be captured in photographic reproduction.

Günter Umberg lives and works in Cologne. After an early career in lithography, he turned to painting in the early 1970s, using graphite pigments. In the 1980s, he began using primarily black pigments of various kinds. For six years, he ran an exhibition space in Cologne (the Space for Painting), in which he showed the work of artists concerned with similar problems and issues in the practice of painting. He has exhibited very widely in Europe, Asia, and the United States.[4]

—Peter Nisbet

1. It joins a smaller work, also on aluminum and from the same period (1997.109), as well as two early "drawings" of 1976, in colored pigments in paraffin wax on transparent paper (1997.110, 1997.111).
2. Others of this scale include those in the Staatsgalerie Stuttgart (inv. no. DKM515) and the Städtisches Museum Abteiberg Mönchengladbach (inv. no. 9889).
3. The artist often installs his own exhibitions. But exhibition spaces, however adjusted by the addition of partitions or different wall coverings, are not intended as encompassing installations: Umberg's paintings are made without regard to an eventual environment, but they are put in their temporary locations with intense respect for the particulars of the place. The direct address of painting to viewer remains primary, although more or less discreetly guided and nuanced by the artist's interventions.
4. This text has been adapted from the author's introduction, "Günter Umberg's Paintings," in Günter Umberg, Harvard University Art Museums Gallery Series No. 22 (Cambridge, Mass., 1997), 3. That exhibition brochure also contained statements by and an interview with the artist, suggestions for further reading in English, and installation photographs of the artist's exhibition at the Busch-Reisinger Museum (23 May–24 August 1997), his first solo exhibition at a North American museum.

SIGMAR POLKE

1941 Oels (Silesia), Germany

Untitled (Abstract Red Transparent Picture
with Arrow Pointing Upward)
(Ohne Titel [Abstraktes rotes Transparentbild
mit Aufwärts-Pfeil])

1990
Mixed media on polyester fabric
117.3 x 137.5 cm
Gift of AXA on the occasion of the 100th
Anniversary of the Busch-Reisinger Museum,
2003.63

1. Originally published by the donors of this
painting in *AXA Art: Corporate Collecting Today*
(Cologne, 2001), 62–63, 253, under the title
*Untitled (Abstract Red Banner Painting on Film,
with Upward-Pointing Arrow)*. The artist pro-
vided the German title.
2. Paul Groot, "Sigmar Polke," *Flash Art* 140
(May–June 1988): 68.
3. Much is mentioned of the influence on
Polke of Francis Picabia, whose 1924–32
series of canvases called Transparencies con-
tain layered contours and patterns. Marcel
Duchamp is also frequently cited but always,
it seems, in relation to ready-mades and
found images.
4. Equally fanciful, perhaps, is my eagerness
to read the purple and pink strokes extending
from upper left to right of *Untitled* as reminis-
cent of the billowing "milky way" occupying
the upper portion of *The Large Glass*.
5. Marcel Duchamp, *Notes and Projects for the
Large Glass* (New York, 1969), 76.
6. Groot, "Sigmar Polke," 67.
7. Sigmar Polke, "What Interests Me Is the
Unforeseeable," *Flash Art* 140 (May–June
1988): 70.
8. Accession nos. 1997.77.1–3.

From apocalyptic to sublime, regenerative to scientific, interpretations of Sigmar Polke's abstract paintings of the 1980s and '90s differ wildly. The variety of readings is encouraged by the beguiling metaphorical possibilities of the paintings' media and techniques as well as the artist's roguish impulse to provoke contradictory interpretations of his work. Frequently referred to as his alchemical paintings, the abstractions, including this work,[1] incorporate unconventional media such as lacquers and resins and, occasionally, chemical substances such as bromide and silver sulfate. Coinciding with these explorations (and presaged by the layering of images and patterns evident in his earlier work), Polke began in 1987 to paint on translucent fabrics that buoy the media and allow for double-sided compositions. Extensively worked on both verso and recto, the color-saturated, semitransparent elements of *Untitled* recede, surface, or obscure one another in a vigorous interplay of layers on sheer polyester fabric.

If, as the artist remarks of his translucent works, "I know everything about glass-painters. St. Luke taught me that,"[2] Polke's expertise must then extend to that larger-than-life figure of painting on glass, Marcel Duchamp.[3] Duchamp's high–low conjunction of metaphysics and lingerie, *The Bride Stripped Bare by Her Bachelors, Even (The Large Glass)* (1915–23, Philadelphia Museum of Art), is composed of oil, lead wire, lead foil, and dust on glass. Polke's untitled painting makes no overt reference to Duchamp's *Large Glass*, yet the gases, fogs, and liquid suspension integral to the bride's stripping—and unpictured in Duchamp's painting—seem to haunt the surface of *Untitled*. This is a fanciful reading, admittedly,[4] but the two artists are acting out of similar concerns. In his copious notes for *The Large Glass*, Duchamp wrote, "Determine the luminous effects (lights and shadows) of an interior source. i.e. that each substance in its chemical composition is endowed with a 'phosphorescence.'"[5] Polke remarked, "To me it is the chemical working of the painting, the alchemy of the color that is important ... the glow in a painting we cannot immediately

place. But they throw an image onto your retina, nonetheless, and stir up a longing for the unknown mystery."[6]

Polke's paradoxical emphasis on materiality is evident in his provocative claims that the process of applying diverse substances supersedes its results, e.g., "The picture isn't really necessary!"[7] Even if overstated, given the considerable beauty of *Untitled*, the point is borne out in the painting, which seems a register of marks—a less calculated iteration, perhaps, of *Moderne Kunst* (1968, jointly owned by Block/Froehlich and Møn/Stuttgart), Polke's one-liner about modernist styles and gestures. A pool of poured green; a purple that drips both downward and up; delicate, blue filigree; swift, gestural application of red with a brush; and linear forms, of no describable color, push through the ether. A spray of dots reminiscent of rasters, those vehicles of Polkean irony, reminds us that the artist's skepticism is present even in abstraction.

Less concerned with the sublime than with the sublimation of chemical substances, more enchanted with the romance of accident than with the German romantic tradition, Polke's exploitation of volatile media undermines his authorial control. Accident is a long-standing partner in Polke's work (most emphatically in his photographic experiments beginning in the early 1970s) but is also its subject. A series of three prints in the Busch-Reisinger Museum reveal isolated instances of printing error, drawing our attention to the fallibility of the process.[8] Polke refuses the authoritative stance: indiscernible in reproduction and elusive in actuality, even the upward-pointing arrow of *Untitled* dodges its direction-giving duties. The linear forms, whether esoteric quotations or fabricated symbols, hint at significance but give nothing away.

—Lisa Lee

Markus Lüpertz

1941 Liberec, Bohemia (now Czech Republic)

Lower Rhenish
(Niederrheinisch)

1991–92
Oil on canvas
81 x 99.8 cm
Promised gift from an anonymous donor in honor
of the 100th Anniversary of the Busch-Reisinger
Museum, 37.2003

1. Armin Zweite, Markus Lüpertz: Gemälde-Skulpturen, exh. cat., Kunstsammlung Nordrhein-Westfalen (Ostfildern, Germany, 1996), 136–38, cat. nos. 48–50.
2. Siegfried Gohr, Markus Lüpertz (Cologne, 2001), 221–23, ill. 178–194.
3. Ibid., 44, ill. 38; 54, ill. 45; 76, ill. 67–69.
4. Homo Homini Lupus: Markus Lüpertz—Krieg, exh. cat., Reuchlinhaus Pforzheim, Galerie der Stadt Stuttgart (Pforzheim, Germany, 1994).
5. "So wenig das Bild ohne Reflexion auf seine Geschichte noch wahrhaftig sein kann, so wenig kann ein Maler in Deutschland Kunstwerke formulieren, ohne im Ungefähren und Geborgten zu bleiben, wenn er nicht den Krieg und was dieser für die Stellung der Kunst bedeutete, in seine bildnerische Analyse einbezieht." Gohr, Markus Lüpertz, 71.

Among the paintings Markus Lüpertz dedicated to the echoes of World War II, Lower Rhenish might be the most intimate. Lüpertz spent many of his childhood years along the Rhine, and he lived in that region when he portrayed it in 1991 and 1992 as the site of some of the bloodiest battles of the two world wars. The painter continues to live in that area, as professor and director, since 1986 and 1988, respectively, of the Düsseldorf Academy of Fine Arts.

Lower Rhenish, a relatively small format, combines a still life—a skull on a uniformed torso and a bunch of flowers in a vase—with a landscape, the wide-open fields of the Lower Rhine region. The representational elements—familiar objects from the baroque vanitas iconography and a landscape reminiscent of Caspar David Friedrich—are subject to a conceptual twist. Bringing together these two unrelated painting traditions, Lüpertz claims sovereignty over his artistic heritage. With painterly bravura, he exploits the irritation caused by the unlikely combination of closeup and panoramic views. Thinly applied, mostly dark colors create interferences and ambivalences. Animated by vivid brushstrokes, the skull seems to turn around on the torso, which is dressed in a ghostly transparent uniform. The jacket, decorated with epaulettes and sash, merges with the loosely painted field behind it. A reddish vase with a bunch of flowers honors or comments upon this nightmarish remnant of National Socialists' blood and soil ideology, transforming it into a grim memorial. Perhaps the gift of a left-behind girlfriend or widow, this ambiguous flower vase might stand for an impossible love. Or are the flowers merely arrows in a quiver, pointing to the convergence of love and death? The vase's shape reminds viewers familiar with Lüpertz's work of what he called the "dithyramb," his most significant formal invention, and as such the bouquet might be seen as the painter's tribute to death. A dithyrambic shape floats on each side of the vase, drifting between representation and abstraction. These shapes are not unlike the curious worms inhabiting the corpses in the late medieval macabre tradition.

Just before Lüpertz painted Lower Rhenish, he worked on a series of Dance of Death reliefs, each depicting a female figure or a skeleton and, unconventionally, an amphora.[1] In those works, Lüpertz played off the horrifying and humorous aspects of the dance of death, aware of their popular moralistic and satirical appeal. Lüpertz created Lower Rhenish as one of fifty-four parts of the cycle The Artist's Dream: Painter's Street Ballad (Traum des Künstlers oder Malermorita), which included painterly improvisations on themes such as execution, war, and Golgotha.[2] In this context, Lower Rhenish refers to some of Lüpertz's most ambitious—and controversial—earlier works. They evoked German memories of World War II by placing military objects in open fields. The gigantic Westwall (200 x 1250 cm, 1968, Goethe Collection, Duisburg), was inspired by the concrete cubes fortifying Nazi Germany against French tanks. Sinking Helmets (1970, Stoffel Collection, Cologne) and the triptych Black–Red–Gold I, II, III (1974, Galerie der Stadt Stuttgart) show parts of uniforms artificially arranged in open spaces.[3]

It has been suggested that the first war in the Persian Gulf gave Lüpertz cause to revisit that earlier concept in 1991 and 1992.[4] In Lower Rhenish, for the first time he places a skull instead of empty helmets in the center of a wide horizon, making the confrontation with death a personal experience. To some observers, this memento mori expresses the burden the German past still imposes on the present, a macabre sense of being familiar with death. Lüpertz risks articulating this feeling with forms deeply rooted in painterly conventions, striving for a precision described by art historian Siegfried Gohr: "Today, just as no image can be true without reflection on its own past, no painter in Germany can formulate an artwork which is to be neither vague nor eclectic, without making consideration of the [second world] war and its impact on art a part of his or her artistic analysis."[5]

—Joachim Homann

ADDENDA

As this volume goes to press, we are delighted to report two further birthday presents, which unfortunately arrived too late to receive full entries.

FRANZ VON STUCK
1863 Tettenweis, near Passau, Germany | 1928 Munich, Germany

Amazon
(Amazone)

1897 (cast after 1905)
Bronze
64.2 x 46.4 x 17.3 cm
Anonymous gift in honor of the 100th Anniversary of the Busch-Reisinger Museum, 2003.132

WILLI GEIGER
1878 Schönbrunn, near Landshut, Germany | 1971 Munich, Germany

Death on a Horse
(Reiter Tod)

1901
30.9 x 23.4 cm
Black, white, and colored chalks, red paint, gouache, brown ink, gray wash, and graphite on off-white laid paper
Gift of Dr. Hinrich Sieveking in honor of the 100th Anniversary of the Busch-Reisinger Museum, 2003.131

Chronology of the Busch-Reisinger Museum

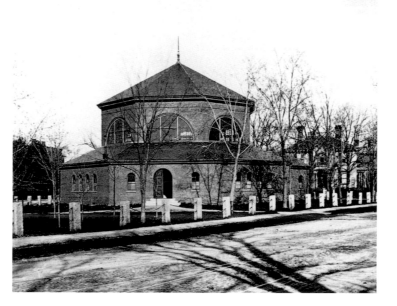

1897

Three Harvard professors of German literature—among them Kuno Francke—publish an article, "The Need of a Germanic Museum at Harvard."

1901

In the United States, an "Association for the Establishment of a Germanic Museum in Cambridge, Massachusetts" is founded.

1902

While visiting Cambridge, where he receives an honorary degree, Prince Henry of Prussia announces that his brother Kaiser Wilhelm II "will make a magnificent gift to the Germanic Museum, which will include [plaster casts of] key monuments in the development of German sculpture."

1903

The Germanic Museum, in Rogers Hall (Harvard's first gymnasium, built in 1859 and torn down in 1933), is dedicated on November 10, the birthday of Martin Luther and Friedrich Schiller. Kuno Francke is curator.

1906

In honor of the Kaiser's silver wedding anniversary, Harvard announces an "Emperor William Fund." This gift of $30,000, donated by American friends of the Germanic Museum, is to be a financial basis for the institution. Adolphus Busch, a German-American brewer from St. Louis, becomes president of the Germanic Museum Association.

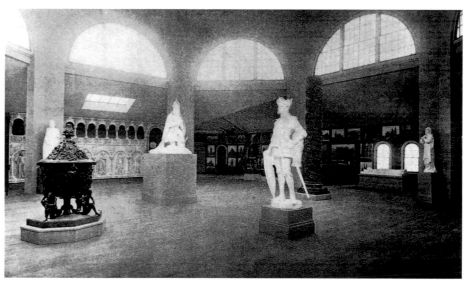

The Museum's first home (1903–21): Rogers Hall, views of exterior and interior (showing plaster casts and framed photographs of architectural monuments).

W. V. Schevill (1864–1951), *Portrait of Adolphus Busch*, copy of the 1896 original by Anders Zorn. Oil, 129.6 x 92.1 cm. Gift of Mrs. Adolphus Busch, BR25.2.

Kuno Francke

Kuno Francke publishes the first edition of the *Handbook of the Germanic Museum* (the seventh revised and final edition is published in 1929).

1910

After Adolphus Busch donates $265,000 for the construction of a new building, a design is commissioned from German Bestelmeyer of Dresden, a prominent historicist architect whose projects include the Central Hall of the University of Munich and an extension to the Germanisches Nationalmuseum in Nuremberg.

1912

After the ceremonial laying of a cornerstone in July, construction of the new building is delayed for two years because of legal problems with clearing the building site.

1913

Adolphus Busch dies.

1914

Construction is begun on the new Germanic Museum in July, a few weeks before the outbreak of World War I. Hugo Reisinger, the son-in-law of Adolphus Busch, dies; he bequeaths the Museum an endowment of $50,000.

1916

Work on the new building proceeds, with interruptions, in an atmosphere of increasing anti-German feeling in the United States. Bestelmeyer never sees the building; construction is supervised by Langford Warren.

1917

The white plaster casts are moved to Busch Hall. After the United States enters the war against Germany and anti-German feeling peaks on campus, Francke resigns his professorship and moves to the country. He retains his position as honorary curator of the Germanic Museum, which, however, remains closed indefinitely for "lack of coal."

1921

In April, Adolphus Busch Hall is dedicated and the Germanic Museum reopens. Fifty thousand people visit in the first twelve months.

1927

The William Hayes Fogg Art Museum opens its new building on Quincy Street.

1927 – 28

As there is no specialist in German art at Harvard, two guest professors from Germany lecture, using the collection of the Germanic Museum: in 1927, Adolph Goldschmidt, from the University of Berlin, and the following year, Gustav Pauli, from the Kunsthalle in Hamburg.

1929

Before the stock market crash, an endowment of $150,000 is raised for a Kuno Francke Professorship of German Art and Culture, a chair that continues today in Harvard's Department of Germanic Languages and Literatures.

1930

Kuno Francke dies on June 25. The Germanic Museum, which has been connected with the Department of Germanic Languages and Literatures since its founding, is placed under the supervision of the Fogg Art Museum and the Fine Arts Department, although the Museums' visiting committees are not combined until 1964. Until then, the Germanic Museum is served by the visiting committee of the German Department. A young Harvard-trained art historian, Charles L. Kuhn, becomes curator with a part-time teaching appointment and institutes the new policy of collecting original works of art from Central and Northern Europe. He also initiates a program of temporary exhibitions.

1931

The Museum's first temporary exhibition is devoted to German printmaking from the 15th century to the

present. One of Kuhn's first acquisitions is a contemporary monumental sculpture by Ernst Barlach.

1932-33

The Museum presents two exhibitions of photography, the first at the Harvard University Art Museums.

1935-37

Two murals are painted by Lewis W. Rubenstein, Harvard '30, in the foyer of Adolphus Busch Hall. The frescoes are modern interpretations of ancient Nordic legends.

1937

At the behest of the celebrated organist E. Power Biggs, an organ on long-term loan from the Aeolian Skinner Company is installed in Adolphus Busch Hall's Romanesque Hall. Biggs proceeds to play the complete organ works of J. S. Bach in twelve recitals at the Museum.

1939

The Harvard Department of Germanic Languages and Literatures moves its offices into Adolphus Busch Hall. Kuhn is made associate professor of fine arts and becomes a full professor in 1955.

1939

The Curt von Faber du Faur Library of seven thousand German books (15th to 19th century) is loaned to the Museum and installed in one of the galleries. The collection is eventually donated to Yale University.

1940-41

The Museum presents pioneering exhibitions of the work of Paul Klee, Max Beckmann, and Franz Marc.

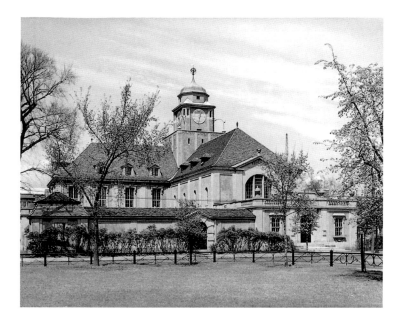

The Museum's second home (1921–87): Adolphus Busch Hall, views of exterior (Kirkland Street facade) and interior (c. 1925, showing Renaissance Hall with plaster casts).

Charles Kuhn

1941

While very few works of modern art—mainly a small number of prints—are acquired between 1938 and 1948, the purchase of Max Beckmann's masterpiece, *Self-Portrait in Tuxedo* (1927), brings the Museum's signature painting to Cambridge.

1942

After the United States enters World War II, the Germanic Museum is closed again indefinitely. Its art collection and library are moved into storage at the Fogg. The building is used as a staff headquarters for the U.S. Army Chaplain School. E. Power Biggs gives weekly Sunday morning organ recitals, which are broadcast nationwide by CBS Radio until 1958.

1946

At the end of the war, the Museum is in a precarious financial position. Kuhn writes, "Most of the original works of art which have been deposited at the Fogg Museum during the past four years must remain in that institution for adequate care. The public lectures, concerts and elaborate loan exhibitions, which were regular features of the Museum prior to the War, must to a large measure be discontinued." Kuhn proposes that the institution become a "study center for Germanic culture."

1947

Prompted by Fogg director John Coolidge, Kuhn begins to assemble a collection documenting the Bauhaus, with the assistance of Bauhaus founder Walter Gropius, who joined the faculty of Harvard's School of Architecture in 1937.

1948

A $5,000 donation from Edmée Busch Greenough, the daughter of Adolphus Busch, allows the Museum again to augment and exhibit its holdings.

1949

Edmée Busch Greenough donates $200,000.

Kuhn becomes chairman of Harvard's Department of Fine Arts, a position he holds until 1953.

1950

In recognition of enormous support through the years from the Busch and Reisinger families, the Museum is renamed the Busch-Reisinger Museum of Germanic Culture. (In 1981, the name is changed to Busch-Reisinger Museum of Central and Northern European Art and in 1990 is shortened to Busch-Reisinger Museum.) The largest exhibition hall is named the Kuno Francke Memorial Gallery.

At a high point in his postwar collecting, Kuhn acquires an extraordinary group of masterpiece paintings by Lyonel Feininger, Erich Heckel, and Ernst Ludwig Kirchner, as well as a number of drawings. The Museum presents the first comprehensive U.S. retrospective exhibition of Kirchner's work.

1951

Plaster casts are removed from the small entrance gallery and are replaced with Gothic sculpture from the collection of the Fogg Art Museum.

1953

The Eda K. Loeb Endowment is established to support curatorial activities.

The Museum receives the Arthur Kraft Collection of late-19th-century German art, including works by Lovis Corinth, Max Liebermann, Max Slevogt, and Lesser Ury.

1955

The Metropolitan Museum of Art, New York, donates a large group of textile samples by the Wiener Werkstätte (Viennese Workshops).

1957

The German art historian Hans Maria Wingler studies the Museum's Bauhaus collection. The following year, as newly appointed director of the Bauhaus-Archiv in Darmstadt, Germany, and funded by the Rockefeller Foundation, Wingler returns as a research fellow.

Kuhn defines his priorities in his annual report: "It is believed that the long-term usefulness of the Museum to the University programs of teaching and research will eventually depend on the extent and quality of the works of Germanic art available to teachers and scholars. The curator recognizes the importance of temporary exhibitions as an answer to the immediate needs of the University and as a stimulus to interest in the Museum itself. Unfortunately the shortage of staff and of resources prevents the Museum from pushing both aspects of its program with equal vigor. It becomes necessary, therefore, for acquisitions to take priority over the current program of activities."

J. B. Neumann donates his collection of late-18th- and early-19th-century German prints.

Kuhn publishes the catalogue *German Expressionism and Abstract Art: The Harvard Collections*; a supplement comes out in 1967.

1958

An organ by D. A. Flentrop of Zaandam, Holland, is first anonymously loaned, then donated to the Museum. E. Power Biggs uses the instrument, which is designed to produce the pure and clear tone of the baroque organs on which Bach composed, for concerts and recordings.

Acquisitions in memory of Louis W. Black (Harvard AB '26, AM '27, LLB '30), a major donor of modern prints to the Museum, include important expressionist drawings and prints.

1958-59

The permanent collection in Adolphus Busch Hall is rearranged, and only the most significant plaster casts remain on view. Original medieval art is installed in the "chapel" area, together with stained-glass panels lent by the Benedictine Priory of Portsmouth, R.I. Decorative arts occupy the ground level of the Francke Memorial Gallery, whose balcony accommodates 20th-century art.

1960

Julia Phelps, lecturer in German, is acting curator for a year.

1961

Walter R. Davis establishes the Antonia Paepcke DuBrul Fund for the Acquisition of Works of Art.

Alexander Dorner bequeaths his modern art collection, some of which had been given in 1957–58. It includes important examples of constructivist art of the 1920s by Naum Gabo, El Lissitzky, László Moholy-Nagy, and Friedrich Vordemberge-Gildewart.

1962

Kuhn selectively deaccessions paintings and works on paper from the modern collections; the process continues in 1963 and 1965.

1962-63

The Harvard Fine Arts Library is created by merging the former Fogg and Busch-Reisinger museum libraries with the fine arts collections from Harvard's Widener Library.

1963

The Feininger Archive is established. This resource includes 5,400 sketches, thousands of letters (deposited at Harvard's Houghton Library), unfinished canvases, photographs, and woodcuts given by the artist's widow. Further gifts of material for the Archive are received in 1965, 1971, and 1986.

1965

In an effort to consolidate and define the collections of both the Fogg and Busch-Reisinger museums, early Flemish, Dutch, and German paintings and sculpture are transferred to the Busch-Reisinger, and Central and Northern European prints are transferred to the Fogg. This exchange is reversed in 1990.

A Care of Collections Endowment is given by an anonymous donor.

Kuhn publishes *German and Netherlandish Sculpture 1280–1800: The Harvard Collections*.

1968

After thirty-eight years as curator, Charles Kuhn retires.

In his concluding annual report, he writes that since "Germanic art is now regarded as one facet of a European cultural manifestation, ... the Busch-Reisinger's program should reflect this emphasis. ... Future exhibitions illustrating the position of German art in Western Civilization would prove of enormous value to the study of cultural history."

In honor of his retirement, the Charles L. Kuhn Endowment Fund is established, "to be devoted primarily to the presentation of significant exhibitions" at the Museum.

1969

John David Farmer, a Renaissance scholar, becomes curator and lecturer in fine arts.

Walter Gropius donates his archive to the Museum. The material includes correspondence, drawings, prints, and photographs documenting the first forty years of his career in architecture.

1971

The Museum publishes *Concepts of the Bauhaus*, a full catalogue of the Bauhaus holdings, and mounts an accompanying exhibition.

1972

Hedy Landman, an art historian with a wide range of interests, becomes acting curator until 1974.

The Museum organizes *German Master Drawings of the Nineteenth Century*, the first scholarly exhibition in North America devoted to this topic.

1974

Linda Seidel, a specialist in Romanesque sculpture, becomes acting curator and lecturer in fine arts.

A proposal to make Adolphus Busch Hall into a museum for modern art encounters stiff opposition.

1975

Charles Werner Haxthausen, a specialist on Paul Klee, becomes curator and half-time professor until 1983. The Busch-Reisinger begins a fundraising campaign and substantial discussions of the Museum's future role. The Busch-Reisinger Museum Endowment Fund is established "to bring the scholarly educational and exhibition program of the museum to the level merited by its growing collections."

Romanesque Hall is renamed in honor of Charles Kuhn.

Gabriella Jeppson, an arts administrator specializing in modern art, is acting curator. During this year, and every year until the Museum moves from Adolphus Busch Hall in 1987, the attendance averages thirty thousand.

1980

With Abbeville Press, New York, the Museum publishes *The Busch-Reisinger Museum, Harvard University*, a richly illustrated book of collection highlights.

1980-81

In an effort to increase the Museum's visibility in the U.S., masterpieces from the 20th-century collection are shown at the National Gallery in Washington and the Wildenstein Gallery in New York. Total attendance is 130,000.

Architectural historian Winfried Nerdinger of the Technical University, Munich, reorganizes and catalogues the Walter Gropius Archive. The Archive is presented in an exhibition and scholarly catalogue in 1985, and all the visual materials are published in three volumes in 1990.

1981

The Volkswagen Foundation establishes a five-year visiting professorship for prominent scholars from Germany to combine research at the Museum with teaching in Harvard's Fine Arts Department.

1982-83

In a campaign to promote the Museum across the Atlantic, masterpieces from the 20th-century collection are shown in Germany at the Städel in Frankfurt, the Bauhaus-Archiv in Berlin, and the Kunstmuseum Düsseldorf. Total attendance is 70,500. The Städel publishes a German-language catalogue, with essays by students in a seminar led by Charles Haxthausen.

1983

Peter Nisbet becomes curator.

A Friends of the Busch-Reisinger Museum foundation is established in the Federal Republic of Germany. By 2003 this association numbers some 245 members in Germany, Austria, Switzerland, and elsewhere.

The Museum's third home (1987–91): Warburg Hall, the south wing of the Fogg Art Museum, views of exterior (c. 1927, from Harvard Yard) and interior (1989, with part of a temporary exhibition, *Twelve Artists from the German Democratic Republic*).

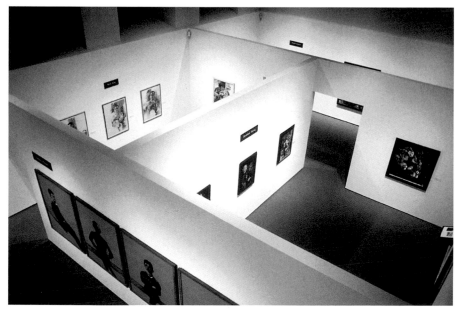

Dr. Werner Otto

1984

The Museum presents the first U.S. exhibition of drawings by Joseph Beuys.

Lufthansa German Airlines donates three important contemporary paintings, by Gerhard Richter, Konrad Klapheck, and Gotthard Graubner.

1985

The Arthur M. Sackler Museum opens to house the Art Museums' collections of Islamic and later Indian, Asian, and ancient art.

1986

A decision is made to work toward a new building for the Busch-Reisinger Museum, to be attached to the Fogg Art Museum.

The Daimler-Benz company, in honor of its centennial, donates funds to endow the curatorship of the Busch-Reisinger Museum. Peter Nisbet is appointed the Museum's first Daimler-Benz Curator in 1988.

1987

While awaiting completion of the new building, the Busch-Reisinger Museum moves into temporary quarters in the Fogg (Warburg Hall). The back galleries, basement, and upper floors of Adolphus Busch Hall are renovated and leased until 2037 to Harvard's Minda de Gunzburg Center for European Studies. The Harvard University Art Museums retain control of the medieval galleries, which include the Flentrop organ.

The Busch-Reisinger Museum donates 19th-century Swedish peasant furniture and objects (acquired in 1952) to the American Swedish Institute in Minneapolis.

The government of the Federal Republic of Germany initiates a five-year program to assist with the expenses for the Museum's curatorial staff.

The collection of Dr. Fredric Wertham, including a highly important group of 1920s abstract paintings and works on paper, is bequeathed by his widow, Hesketh. A full catalogue of this gift is published in 1990.

1987-88

The Museum organizes El Lissitzky 1890–1941 with the Sprengel Museum Hannover and the Staatliche Galerie Moritzburg, in Halle. The exhibition is the first to be jointly undertaken by institutions in the United States, the Federal Republic of Germany, and the German Democratic Republic.

1988

Gwathmey Siegel & Associates of New York is chosen to design the new building for the Busch-Reisinger Museum, to be named Werner Otto Hall in honor of its principal donor. The Otto Hall project also encompasses the Susan Morse Hilles Reading Room for the Fine Arts Library, new office space for library staff on two levels, and the Philip and Lynn Straus Gallery for works of art on paper in the Fogg building.

The Cultural Council of the Federation of German Industry begins a multiyear philanthropic initiative to enrich the Museum's collections of postwar German painting, sculpture, and, especially, photography.

1989

The Museum organizes the first U.S. exhibition of art from East Germany, *Twelve Artists from the German Democratic Republic*.

1991

Werner Otto Hall is dedicated on September 28–29 and opens to the public on October 1.

The Busch-Reisinger Museum: History and Holdings is published. A fully illustrated guide, it includes historical documents, an account of the growth of the collections, details on the Museum's buildings, a list of exhibitions, and a summary chronology.

1992

The German Art Dealers Association initiates and organizes gifts of more than two hundred postwar German drawings and prints. A full catalogue is published in 1998.

The Museum acquires the complete editioned photographs and prints of Bernd and Hilla Becher (1968–91).

The Estate of Ernst Teves establishes an endowment fund to support educational activities of the Museum.

1994

A donation from Gabriele Geier establishes an endowment fund for the Museum's curatorial activities.

1995

The Museum purchases the Willy and Charlotte Reber Collection of works by Joseph Beuys, including an almost complete set of the artist's multiples. Charlotte Reber donates her research library on Beuys. The Museum copublishes an updated English edition of the catalogue raisonné of Beuys's multiples in 1997.

1995-97

A program of Visiting Curatorial Fellows, funded by the Friends of the Busch-Reisinger Museum, brings museum and university colleagues for extended stays (Siegfried Gohr, Ute Eskildsen, Hans Belting, Hans Dickel, Boris Groys).

1996

An endowed fund to support studies in the arts is established by the bequest of Ilse Bischoff, a longtime supporter of the Museum who was instrumental in building up the collection of 18th-century porcelains.

The Museum's fourth home (since 1991): Werner Otto Hall, views of exterior (from Prescott Street) and interior (galleries for the permanent collection).

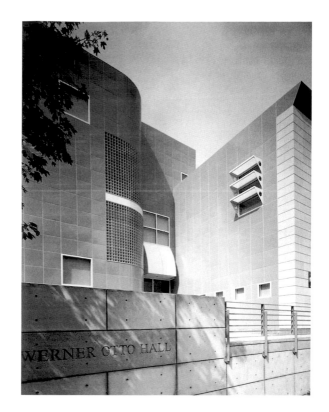

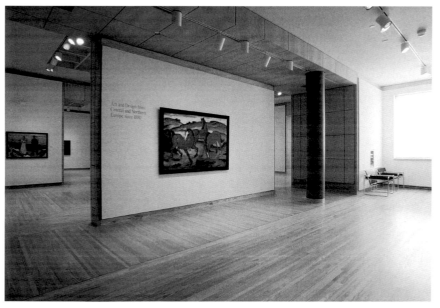

Eva Weininger donates 34 works on paper of the 1920s and 1930s by her late husband, Andor Weininger. The Museum publishes a full catalogue of the gift in 2000.

1997-98
The Museum organizes the exhibition of the Winterstein collection of German drawings and watercolors in the age of Goethe, with a scholarly catalogue and an international tour.

2000
Donations establish the Rendl Fund for Slavic Art and the Emilie Norris Fund for the Museum's Study Room, named to honor Norris's long service to the Museum, most recently as assistant curator. Laura Muir, a specialist in the history of photography, is appointed assistant curator in 2001.

2002
The Museum publishes a 250-page guide to teaching with the permanent collection and presents its first web-based exhibition, devoted to aspects of the Bauhaus holdings.

2003
Members of the family of Christoph Engelhorn endow the Stefan Engelhorn Curatorial Internship in the Busch-Reisinger Museum. This internship will replace the annual gifts that have supported the Werner and Maren Otto Curatorial Internship (1995–2004), and run alongside the Michalke Curatorial Internship (1999–2009).

The Museum publishes *Birthday Presents: Acquisitions for the 100th Anniversary of the Busch-Reisinger Museum.*